# Brilliant Digital Photography

## John Skeoch

PEARSON

Prentice
Hall

Harlow, England • London • New York • Boston • San Francisco • Toronto • Sydney • Singapore • Hong Kong
Tokyo • Seoul • Taipei • New Delhi • Cape Town • Madrid • Mexico City • Amsterdam • Munich • Paris • Milan

**Pearson Education Limited**
Edinburgh Gate
Harlow
Essex CM20 2JE
England

and Associated Companies throughout the world

*Visit us on the World Wide Web at:*
www.pearsoned.co.uk

**First published 2007**

ISBN-13: 978-0-13-613238-7
ISBN-10: 0-13-613238-3

**British Library Cataloguing-in-Publication Data**
A catalogue record for this book is available from the British Library

**Library of Congress Cataloging-in-Publication Data**
A catalog record for this book is available from The Library of Congress.

10 9 8 7 6 5 4 3 2 1
10 09 08 07 06

Prepared for Pearson Education Ltd by Syllaba Ltd (http://www.syllaba.co.uk).
Typeset in 12pt Arial Condensed by 30
Printed and bound in Great Britain by Ashford Colour Press Ltd, Gosport.

*The publisher's policy is to use paper manufactured from sustainable forests.*

# Brilliant guides

## What you need to know and how to do it

When you're working on your PC and come up against a problem that you're unsure how to solve, or want to accomplish something in an application that you aren't sure how to do, where do you look? Manuals and traditional training guides are usually too big and unwieldy and are intended to be used as end-to-end training resources, making it hard to get to the info you need right away without having to wade through pages of background information that you just don't need at that moment – and helplines are rarely that helpful!

*Brilliant* guides have been developed to allow you to find the info you need easily and without fuss and guide you through the task using a highly visual, step-by-step approach – providing exactly what you need to know when you need it!

*Brilliant* guides provide the quick easy-to-access information that you need, using a detailed table of contents and troubleshooting guide to help you find exactly what you need to know, and then presenting each task in a visual manner. Numbered steps guide you through each task or problem, using numerous screenshots to illustrate each step. Added features include 'See also' boxes that point you to related tasks and information in the book, while 'Did you know?' sections alert you to relevant expert tips, tricks and advice to further expand your skills and knowledge.

In addition to covering all major office PC applications, and related computing subjects, the *Brilliant* series also contains titles that will help you in every aspect of your working life, such as writing the perfect CV, answering the toughest interview questions and moving on in your career.

*Brilliant* guides are the light at the end of the tunnel when you are faced with any minor or major task.

## Author's acknowledgements

I would like to thank Matt Powell for his introduction, Sally and Karen at Syllaba for their kind words and assistance. Thanks also to Steve for lending a hand when I needed it. Canon deserve recognition for their loan of equipment, and last but definitely not least, Antony for his excellent photography.

## Dedication

To Louise, without whose motivation and support this book might never have happened.

## Publisher's acknowledgements

The author and publisher would like to thank the following for permission to reproduce the material in this book: Antony Lees who took all the photographs, Canon, MAGIX AG, PhotoBox SK, Media Innovations Group Ltd and Fotolia.

Microsoft product screen shots reprinted with permission from Microsoft Corporation.

Every effort has been made to obtain necessary permission with reference to copyright material. The publishers apologise if inadvertently any sources remain unacknowledged and will be glad to make the necessary arrangements at the earliest opportunity.

## About the author

John Skeoch has been making photographs for the past two decades and works on the South Coast as a professional photographer and freelance technical writer. He's written for a wide variety of magazines including *Digital Camera Shopper* offering everything from highly technical reviews to simple step-by-step guides.

# Contents

# Preface

For many, the most involvement they have with cameras begins and ends on annual holidays, at weddings or on the equally joyful occasion of a new baby, but photography can be an incredibly engaging pastime in its own right. In this book we aim to guide you right from the point of deciding to purchase a digital camera, through the pitfalls, on to choosing the right one, and out to the other side where you'll learn just what your camera is capable of and how you can exploit your newly learnt skills.

Unlike the photography books of old you won't have to get your hands wet handling toxic chemicals or develop an unhealthy preoccupation with dark rooms and red lights. Creating perfect prints can literally be achieved from the comfort of your swivel chair. We'll show you, through a series of simple tasks, both with the camera and on the computer, how you can produce striking images that you can even earn money from. All of the images included in this book were taken with equipment easily available to amateur photographers. We won't assume any previous knowledge so you can literally start from scratch. However if you have used a conventional film camera before, many of the photographic techniques maybe familiar to you, the advantage here is you can learn how to polish the results further by using applications such as the industry benchmark in photo manipulation, Adobe Photoshop CS, or the popular home version Elements 4.0.

Like it or not, traditional film is getting harder and more expensive to buy, much less get developed. You've probably already had an enthusiastic sales person try and sell you on the benefits of 'Going digital'. The problem is that however well intentioned they are, they never have the time to really help with all the terminology or basic questions like 'How exactly do you get your pictures?' or 'What does the P stand for?' From this starting point it's easy to understand why digital photography can appear inaccessible, combining as it does the complexity of photography with the equally opaque world of computers. This book has a strong emphasis on hands-on learning with step-by-step guides designed to help fill in all the blanks for beginners, whilst still acting as a great reference tool for those who want to advance to more ambitious projects. In the opening chapters we will set about dispelling some of the daunting myths of digital photography by breaking down what exactly a digital camera is and by understanding how they work you'll have a better idea of their limitations as well.

*John Skeoch, 2006*

# Introduction

Welcome to *Brilliant Digital Photography*, a visual quick reference book that shows you how to make the most of your digital camera and its associated software. Whether you're a diehard film enthusiast or simply bamboozled by computers, there's no denying digital photography is taking over. This book will guide you through a series of tasks designed to familiarize you with the technology available enabling you to capture your own vivid images, print your own family album and potentially even sell your work. We cover every aspect of digital photography from helping you select your ideal camera and getting the best from your equipment, right through to publishing your work on the Web or getting your images onto canvas. Unlike conventional film photography you don't need to have your own dark room to edit your images and this volume will include numerous tips, from removing red eye and cropping to advanced techniques for digital retouching.

## Find what you need to know – when you need it

You don't have to read this book in any particular order. We've designed the book so that you can jump in, get the information you need, and jump out. To find the information that you need, just look up the task in the table of contents or Troubleshooting guide, and turn to the page listed. Read the task introduction, follow the step-by-step instructions along with the illustration, and you're done.

## How this book works

Each task is presented with step-by-step instructions and annotated illustrations on the same page. This arrangement lets you focus on a single task without having to turn the pages too often.

## How you'll learn

**Find what you need to know – when you need it**

**How this book works**

**Step-by-step instructions**

**Troubleshooting guide**

**Spelling**

**The camera**

## Step-by-step instructions

This book provides concise step-by-step instructions that show you how to accomplish a task. Each set of instructions includes illustrations that directly correspond to the easy-to-read steps. Eye-catching text features provide additional helpful information in bite-sized chunks to help you work more efficiently or to teach you more in-depth information. The 'For your information' feature provides tips and techniques to help you work smarter, while the 'See also' cross-references lead you to other parts of the book containing related information about the task. Essential information is highlighted in 'Important' boxes that will ensure you don't miss any vital suggestions and advice.

## Troubleshooting guide

This book offers quick and easy ways to diagnose and solve common problems that you might encounter, using the Troubleshooting guide.

## Spelling

We have used UK spelling conventions throughout this book. You may therefore notice some inconsistencies between the text and the software on your computer which is likely to have been developed in the USA. We have however adopted US spelling for the words 'disk' and 'program' as these are becoming commonly accepted throughout the world.

## The camera

The author used a Canon Powershot A700 (compact digital) camera to prepare this book. However, he has aimed to make his instructions as generic as possible so that whichever camera you are using, you will find it easy to follow.

By now you should be sensing a theme – the histogram is your friend, in fact it's more than a friend, it's pretty much vital. The reason behind this is that your camera or more specifically its display, has a nasty habit of lying to you, its nothing personal but big bright displays sell cameras, accuracy isn't much of a selling point, yet. Camera displays are generally not accurate representations of the outcome of the photo. This is where the histogram becomes such a key tool. If you learn to make use of the histogram and disregard the appearance of the image for all but the framing you will find the amount of time you spend having to brighten and generally tweak your images will be cut by half. This task will cover the use of both playback and live histograms.

**Use the histogram**

**Live Histogram**

**1** We will first look at live histograms. Assuming it has one, activate your camera's live histogram by repeatedly pressing the display button until the moving mountain range pops onto the screen. On the current crop of digital compacts, the histogram will typically be a combined RGB one. This means all the colour information is shown in one wave. Some high-end cameras however, go a stage further and show each colour separately.

**2** You will notice as you move the camera, the mountain range undulates, swaying from left to right as the view gets darker and lighter respectively.

**3** Typically the histogram is split into five segments representing from left to right, very dark (shadow detail), dark, mid (18% grey), light, and finally highlights.

## Troubleshooting guide

**Why do my photos come out blurred?**

It's likely your exposure is set very long either because there isn't enough light, or you have simply selected a slow shutter speed. Try using flash by reading up on page 00 or adjusting the shutter speed in our section on shutter priority on page 00.

**Why are my photos too dark?**

Could be you have accidentally disabled your flash? Check out page 00 for more details or you might need some help using the manual mode, if so read up on page 00.

**Why do my photos vary from too light to too dark?**

Check your metering settings, you might find the camera is set to use spot metering to learn more about the various metering modes turn to page 00.

**My photos all have white skies with no detail, what can I do?**

Ultimately most digital cameras have to make a compromise between exposing the sky or the buildings, however you could try using auto bracketing, read more on page 00.

**How do I stop my photos appearing grainy?**

Grainy photos can be caused by too little light or too high an ISO setting on the camera, check out page 00's task focused on ISO to learn more.

**Whenever I take photos indoors, they come out orange what am I doing wrong?**

Getting a strong colour cast of this nature is usually associated with the wrong white balance settings, check page 00 to get the low down.

**Why can't I get my prints any bigger?**

If you're struggling to get enlargements printed its most likely cause is that the image resolution is set too low. Otherwise it could be you that have been using the digital zoom, learn more about digital zoom on page 00.

**Why do the eyes of my subjects always appear red?**

What you're seeing is the light bouncing back from your subject's eye. There are ways to reduce this in the camera, see page 00 but if they persist you can ensure they are removed in Photoshop, see page 00.

# Getting the best from your camera

## Introduction

It's not hard to understand why many people find digital photography inaccessible with its heady blend of photographic terminology spiced up with more than a pinch of computing acronyms. This book is the answer to manuals which assume you already understand the plethora of photo phrases and magazine articles which omit the vital snippets of information considering it common knowledge. We will kick off straight away with a series of simple tasks that will familiarize you with your camera's layout. Even if you feel relatively comfortable with your digital camera its worth taking some time to review these tasks because the better your grasp of the basics the more likely it will be that you will successfully realize your photos in real-life situations.

## What you'll do

**Understand what a digital camera is**

**Format your memory card**

**Practise with a two-stage shutter release**

**Get the most from an auto-focus camera**

**Use your zoom, optical and digital**

**Get the best from your built-in flash**

**Record short movies**

**Use the TV playback**

**Get your pictures onto your computer**

**Install and use a card reader**

# What is a digital camera?

First of all it's important not to be anxious about digital cameras, after all they're not massively different from any conventional film cameras. The principal components are much the same, there's a light-tight box with an aperture, a lens, a shutter and a light-reactive component, the new component that's been added into the mix is a tiny computer which controls the whole shooting match. While it's true the more you pay the more gadgets you get, besides the computer, the basic elements that make up any camera are identical from the most cutting edge back to Kodak's iconic Box Brownies and before. Remember the best photographers can produce exceptional images armed with nothing but a compact camera, the strength of their imagination and a solid understanding of the principles of photographic practice. Ultimately even the most automated and expensive camera can't make up for a lack of understanding.

Where a digital camera does differ is in the way that it records the light. Conventional cameras relied on various formats of light-sensitive film such as 120mm, 35mm or APS that would be sealed in a roll or canister. The chemicals that made up these films would then react to the burst of light rushing in when you take your snaps, and it wasn't until they were correctly processed in a dark room that the images could be viewed. In a digital camera the film has been replaced by a complex electronic sensor that measures and records the light in order to reproduce the original scene. When you think of the sensor imagine a series of minute wells each of which is filled up by light flowing into it, the amount of that light is then measured. The tiny computer in the camera then uses these samples to reconstruct a digital representation of the complete image. At its most basic the more samples the camera can take the more detailed the image will be.

As a result of this move away from chemical reactions the digital camera enjoys one of its most fundamental advantages over film. Using the same sensor, a digital camera can take literally thousands of photos without wearing out, images which you can review immediately and decide whether or not to keep. Parallels could be drawn between the move from film to digital and the transition from vinyl records to CD. In both cases an analogue system was challenged by a digital alternative. However it's important to note that film is by no means totally superseded by digital, indeed exactly as with vinyl records there are still enthusiasts who prefer the inherent qualities it offers. In a commercial context such as news or sports photography the ease with which digital images can be transmitted or altered has meant that digital cameras have rapidly achieved almost total market dominance. As we will cover in the next chapter the move to digital has affected the way we select our images too, with memory prices in ever-decreasing circles, it's possible to take literally hundreds of images without the need to cull any from the camera.

Before we can start taking photos we need to prepare our tools, and like a painter with a canvas it's best to start with a clean sheet. This task will talk you through how to clear your memory card something which serves a dual purpose: first it removes any unwanted images and second it ensures the card allows us to use its total size. In future you may find yourself relying on Delete to remove unwanted images. However using this when emptying the whole card actually lowers the total available space and as a result how many photos you can take. So it's good practice to use the format command when you are happy it is safe to discard.

1 Turn off the camera

2 Open the memory compartment and insert the memory card, making sure to insert it the correct way round. If you are in any doubt most cameras have a small picture of the appropriate way round beside the slot.

3 Make sure the memory compartment is closed before switching on the camera.

4 Put the camera into its Setup mode, this can be achieved by either pressing the menu button, rotating the dial to the tools symbol or navigating to the camera's Setup option via the menu.

5 Locate the Format option and select it, this is usually done by pressing an OK button or pushing the camera's four-way button to the right to access a submenu.

## Jargon buster

**Memory Card** – this is the digital equivalent of film and is where your images are stored, it is not sensitive to light, however it is good practice to take care with these cards.

**Format** – removes all data from the storage being formatted, similar to simply deleting your images but the process is more thorough.

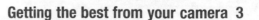

# Format your memory card (cont.)

**Format**

Format memory card? — 6

15.2MB

4.8MB used

Low Level Format

Cancel        OK — 7

6　At this stage the camera will require confirmation asking the question 'Are you sure you want to format?' or something similar. This is to prevent any existing images being accidentally wiped. All cameras default to No and you will need to select Yes to proceed.

7　Confirm that you want to format by pressing OK.

8　The camera will then ask you to wait. Depending on the size of the memory card this will take anything from a second to several minutes.

9　Exit the menu or Setup mode. You are now ready to start taking photos.

## Important

Never force a memory card in, if it won't fit with minimal effort it's likely the card is the wrong way round, misaligned or the wrong type for your camera.

4

Now the camera has its memory card ready and waiting you are all set to start snapping, but before you go off half-cocked it's worth practising how to half-press the shutter release. Just about every camera worth its salt uses a two-stage shutter release. Unfortunately many beginners never get told how to use the shutter release correctly and as a result they stab at the button and fume as the camera pauses momentarily, before seemly remembering what it was doing and finally taking a photo. This pause is often mistakenly referred to as shutter lag, when in fact it is simply the time to focus. To learn more about shutter lag please turn to the Appendix.

By mastering this fundamental skill you will find a far greater number of your images are focused on your desired subject, with moving subjects in the frame and with the details sharp. This task is worth practising regardless of your skill level as the more adept you are, the longer your exposures can be before blurring the photo.

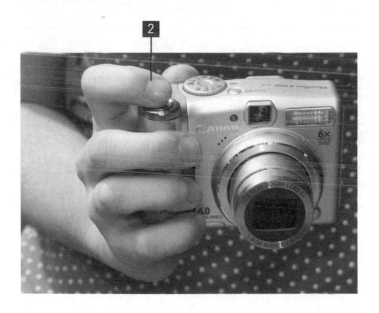

## Practise with a two-stage shutter release

**1** Turn on the camera.

**2** Grip the camera comfortably in your hands with your index finger resting over the shutter release.

**3** Choose a subject and zoom in or out to achieve your desired composition. You can zoom in by pressing the T button or by pulling a dial towards T. If you want to return to the wider view, the W button or dial will zoom out. You can get closer or step back if that helps.

**4** Softly press on the shutter release until you feel a small amount of resistance, when you do don't let go, instead try and keep the button held at this point – you could liken this to keeping a car's clutch on the biting point.

**5** The camera will then focus and the image will snap into clarity, this all takes less than a second but surprisingly even while it is focusing the camera is also working out the available light and the best settings to use.

## Practise with a two-stage shutter release (cont.)

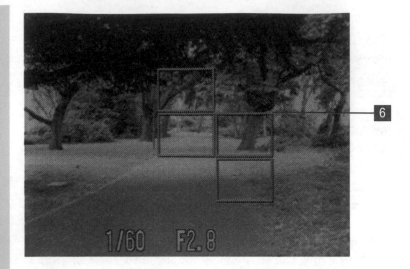

**6** Once the camera is focused there will either be an audible beep, a small green light on the camera or an indication on screen that you are now ready to take your photo. If you fail to get this confirmation you may be too close to your subject or there maybe too little light.

**7** Gently squeeze the shutter release a little more and the camera will take a photo. Do not pull your finger away sharply, instead wait until you are happy the photo has been taken then lift your finger.

### See also

To learn more about using the zoom (and avoiding digital zoom) turn to 'Use your zoom, optical and digital'.

### Jargon buster

**Shutter Release** – the button which releases the shutter and allows it to momentarily snap open and shut, exposing the sensor to light.

Aiming your camera at something squarely in the centre of the display such as one person standing in front of a landmark provides a very simple target for your camera to automatically focus on. However, place two people in the foreground and it's all too easy for things to go horribly wrong. If your holiday snaps have come back from the 1-hour photo shop with sharp backgrounds and bleary blobs where your loved ones once were, this task will help remedy that problem for good. In this task we martial what we've learnt from practising with the two-stage shutter and look at how to use a technique called focus and recompose. This simple process ensures that the focus is as close as possible to the desired subject. It should be noted that this technique is not without its own drawbacks but it's a good place to start. To practise this task you need two people or two objects equal distances from the camera standing apart from each other.

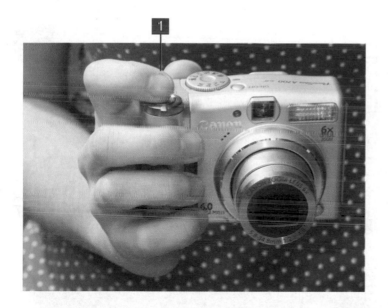

# Get the most from an auto-focus camera

1

**1** Once the camera is on, grip it comfortably in your hand with your index finger resting over the shutter release.

**2** Select one of your subjects and position the target in the centre of the screen or viewfinder. Modern auto-focus systems can show numerous points of focus. Here, the camera has detected several areas that all fall within its focus. The screen indicates each area with a box.

# Get the most from an auto-focus camera (cont.)

**3** Softly press on the shutter release until you feel a small amount of resistance. When you do, continue to keep holding with the same amount of pressure.

**4** The camera will then focus and the chosen subject will sharpen up. Once the camera is focused there will either be an audible beep, or indicator light on the camera or screen. Keep the button held at the same point.

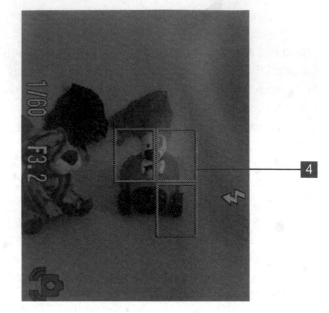

## Jargon buster

**Focus** and **recompose** – auto focus cameras often try and focus on the centre of the scene, which may not be the part you want to be sharp. By pointing at the subject first then recomposing the image you get around this.

## ? Did you know?

Most digital cameras use an automatic focus system that relies on changes in the contrast of a subject to identify where to focus – this is known as Contrast Type AF. So if your camera is struggling to lock on to a subject you might have better luck by aiming at the edge of it.

## Important !

The focus and recompose technique should only be used for small adjustments, if you have to move your feet, you should refocus.

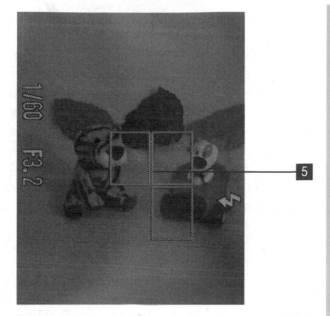

**5** Now adjust the position of the camera to place the centre of the display between the two subjects, ensuring you do not accidentally press too hard and take a picture or let go of the shutter release. If you do make a mistake simply restart the task.

**6** Now once you have both subjects in the frame, squeeze the shutter release and the camera will take a photo. As before, do not pull your finger away sharply, wait until the photo has taken before letting go.

**?**

### Did you know?

Even if you are photographing just one person you should always try and place them one third of the way from the side and the bottom of the image, this has the effect of making the photo more engaging. The name for this technique is the Rule of Thirds and has proved an excellent compositional guideline for artists throughout history.

## Use your zoom, optical and digital

1 Grip the camera comfortably with your index finger over the shutter release.

2 Find a distant subject and position the target in the centre of the screen or viewfinder.

3 Begin zooming into your subject, on most cameras this will be achieved by either pressing the T button or pulling a rocker switch toward either the letter T or an icon for a single tree.

Up and down the country, sales assistants are answering one of the most frequently-asked questions about digital cameras namely what the difference is between optical and digital zoom. The short answer is optical zoom is worth using. However, in all seriousness nearly all modern digital cameras offer a combination of both optical and digital zooms, although the digital zoom is often disabled until selected in the camera menu. Cameras with an optical zoom have several elements in the lens which can move back and forth to magnify the image projected on to the camera's sensor. This type of zoom doesn't affect the image quality and can make it possible to get much closer to the desired subject. When a digital zoom is used, rather than altering the way the light hits the sensor, the camera simply takes the centre portion and enlarges it or conversely crops it to use a smaller portion – which gives the impression the subject is brought closer. However it really degrades the picture quality and often means that the final print looks awful. There are times when a digital zoom can be useful, but try to use it sparingly.

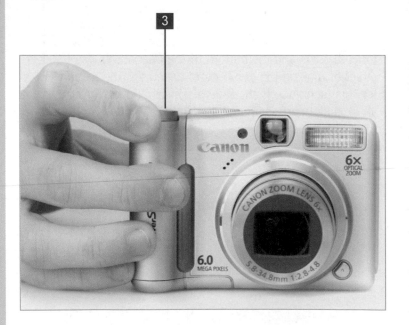

Digital zoom

Optical zoom

4   While the camera is zooming in you will notice that a bar appears on the camera display showing how far through the zoom you are. In some cases the bar will have a line intersecting it, denoting where the optical zoom ends and the digital zoom begins.

5   Experiment by continuing to zoom past the intersecting line, notice the effect on the quality of the image on screen.

6   Once you are happy with the difference between both technologies, press the W button or pull the rocker switch in the opposite direction towards the W or group of trees.

7   Try zooming in and out until your original subject is as large as possible while still only using the optical zoom.

**Did you know?**

Of the digital zooms available, one of the better implementations is the cropping technique. This doesn't employ any additional image processing which can degrade the picture quality, instead it uses a smaller portion of the sensor. For example, setting your camera to 8 megapixels and zooming in 1.8x, will only record a 5 megapixel photo, zooming to 4.8x and you are left with just 1 megapixel.

# Use your zoom, optical and digital (cont.)

8  Now softly press on the shutter release until you feel a small amount of resistance, when you do, continue to keep holding with the same amount of pressure.

9  Once the camera is focused, squeeze the shutter release and the camera will take a photo. Remember to wait until the photo has been taken before lifting your finger.

## For your information

If your camera came supplied with a lens hood or lens petal you should ensure this is always attached, it's not just for sunny weather and should ideally even be used when shooting indoors. Having a lens hood attached helps prevent stray light from hitting the front part of the lens from an acute angle, the effect of which can be to reduce the overall contrast in your photos.

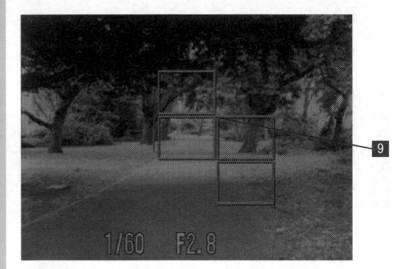

9

## Jargon buster

**Cropping** – in an ideal world, photographers would always get the perfect photo, however the reality is that most photographers select the part of the image they want to use and block out, or 'crop', the surplus.

It's easy to rely on your camera's built-in flash but there will be occasions when even the smartest digital camera can be fooled and you will need to know how to overrule it in order to get the photo you are after. In this task we look at the different modes that are available on a typical digital camera's built-in flash, by taking a series of shots using each of the different modes. Ideally it would be better to try this on a willing volunteer to see the difference each setting can have.

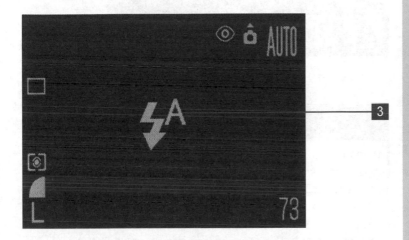

### Did you know?

Although it's common practice to use flash in low light, if you can keep the camera and your subject still enough you can get much more atmospheric photos without it.

### See also

Backlit subjects can be successfully photographed without requiring flash, see Understanding when to use Spot, Centre and Matrix metering.

## Get the best from your built-in flash

**1**

**1** Turn on the camera, if you are already in a darker environment you may have to wait for the built-in flash to charge.

**2** Press the directional pad or button labelled with a crooked arrow or lightning rod, this will access the flash mode selection.

**3** Most cameras use icons to represent the different flash modes. For the first photo select the lightning rod with the word AUTO or the letter A, next to it. (The camera is likely to default to this setting.)

**4** Now take a photo, depending on the available light, the camera will decide whether or not to fire the flash. Try this mode in a variety of conditions to get an idea of how much light is required before it stops flashing.

**5** On the camera press the directional pad or button labelled with the lightning rod to access the flash mode selection again.

# Get the best from your built-in flash (cont.)

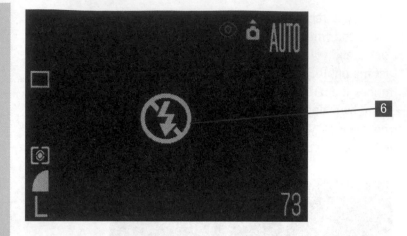

6    This time choose the icon with a struck-through lightning rod – this will disable the built-in flash and rely on using much slower shutter speeds to ensure there is enough light in your photos. The camera display is likely to flash a red hand symbol or blur warning at you so don't be surprised if your test images with this setting appear fuzzy.

7    Go back into the flash menu and this time select the lightning rod on its own. This mode overrides the camera deciding when to use the flash and sets it off for every photo. This mode obviously has a greater drain on the battery but it can be very useful when shooting backlit portraits.

## For your information

When taking photos of people standing in front of a bright light source your camera will try and adjust for the additional light, leaving you with a silhouette rather than the portrait shot you were after. This can be easily be remedied by forcing the flash to fire, effectively filling in the darker areas. This technique is known as fill-in flash.

No flash

Fill-in flash

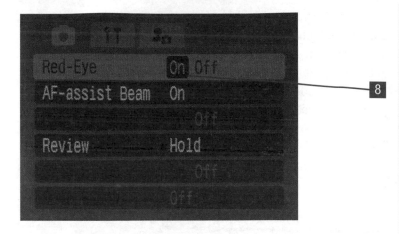

8  The last of the standard flash modes you can select is the lightning rod with a miniature eye next to it. This mode fires not one, but a series of quick flashes, the effect of which is that the eyes or rather the iris of the person you are photographing contract. By making the pupils smaller you avoid the horrible demonic looking effects of 'red eye'.

### Did you know?

Red eye reduction has been round for several years, however despite the ingenious system some red eye can often still remain. Several digital camera manufacturers have developed a new high-tech answer which examines the photo after it's been taken and intelligently removes the red dots afterwards – fine unless you're photographing someone in a polka dot dress!

# Record short movies

For years digital cameras have been able to capture brief snippets of video, however the picture quality was never particularly inspiring and the requirements on memory space and battery life were so prohibitive, that the feature was almost entirely overlooked as a gimmick. However, just as each generation of computers has got smaller and more powerful so too have digital cameras. Now with memory cards available that offer many times the capacity of earlier cards, compact cameras are finally getting to the stage where they are beginning to threaten the world of camcorders.

1 Grip the camera comfortably with your index finger over the shutter release.

2 Switch the camera into movie or video mode by rotating the dial to the camcorder symbol. Alternatively choose the same icon via the camera's menu. To start recording video firmly press and release the shutter release. When capturing video, digital cameras don't use the two-stage shutter release.

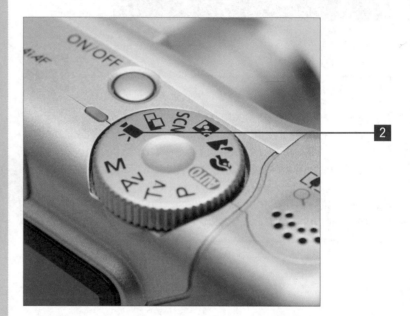

## Important

Make sure you clear any unwanted photos off before you start to use the video mode, it needs a lot of space, unless your camera supports MPEG4.

3 Hold the camera as steady as possible. Unlike camcorders most digital cameras don't yet offer image stabilization on the movie recording.

4 Recording any video will start a counter in the corner of the camera display, the position of which differs depending on your model. This timer can count down the storage space remaining in minutes or simply count out the duration of video.

## Did you know?

Most digital cameras use either a movie format known as QuickTime or AVI which both provide respectable results but require approximately 128Mb of storage per minute of video meaning that even large cards fill rapidly. If your camera has MPEG4 video you are in luck as this advanced format was originally designed for compressing video on the Internet and claims to be able to squeeze around 8 minutes into the same 128Mb.

## Timesaver tip

While you can normally zoom in and out when recording video quite a few cameras actually disable the optical zoom leaving just the digital zoom available, so for the best quality remember to move the optical zoom before switching to video.

# Record short movies (cont.) ▶

5 Try experimenting with the zoom controls, often these buttons will be disabled during video recording.

6 To stop recording simply press the shutter release again. Remember that using the video takes up considerably more memory and battery power than taking still images.

7 Depending on the model of your camera you may be able to view your video immediately. (Most modern compacts also incorporate a microphone and speaker enabling you to listen to short movies.)

## Important ❗

Be mindful of your compact's limitations, specifically the built-in microphones are normally not very good at coping with ambient noise, so try and stand close to your subjects.

## Did you know?

Aside from different compression technologies, some digital cameras are much better equipped to handle video – amongst the better manufacturers Sony and Pentax allow for video clips to be edited while still in the camera. This kind of control is perfect for trimming the video and conserving memory for more photos. *

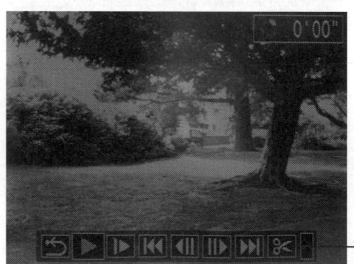

So you've started getting snippets of video and some photos that are a bit better than your usual fare, it's time to show your work off. We'll come to printing your photos later, but for now it's time to take your work centre stage on the household TV. This task will talk you through the step by step process of getting both photos and video on the big screen. Video in particular is extremely useful as this affords you the opportunity to record your new home movies to either DVD or VHS cassettes.

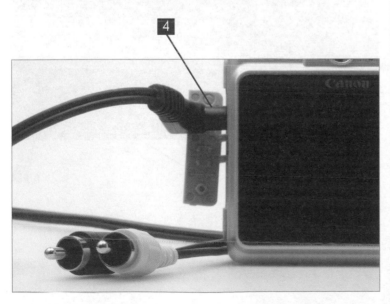

**1** The first step is to check the camera's output mode to the TV. Look for this option under the camera's setup icon if it isn't simply marked as Setup it's probably depicted as a spanner or toolkit. Most cameras switch between NTSC and PAL, you need to select PAL mode which is the UK television standard.

**2** Amongst the cables that came with your camera you should have a cable with a miniature USB or jack plug on one end. On the other end you will normally find two or three connectors, these will be colour coded to identify their purpose. Yellow is for video, red and white stereo sound channels, left and right respectively. On mono systems one of these will be missing.

**3** Playing back video is quite a heavy draw on the camera's power so if your camera can be powered directly it's a good idea to connect the power whilst transferring video or running a slideshow.

**4** Next connect the video cable to the camera using the mini USB or jack connector.

# Use the TV playback (cont.) ▶

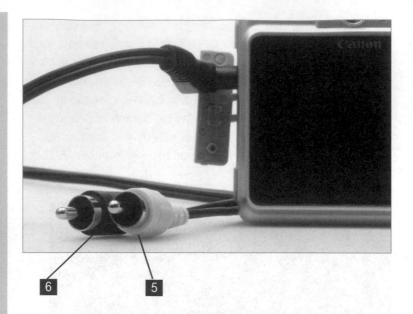

5 Take the yellow colour coded connector and plug it into one of the spare AV sockets on the television. Many modern TVs have a concealed connector on the front designed for use with a camcorder – this is perfect for this purpose. These sockets are conventionally marked as AV1, AV2 or AV3 indicating which channel must be selected to find the video.

6 Beside the video socket on the television you should also find red and white input sockets. Connect your remaining leads to these. You are now all connected ready to watch your videos, complete with sound.

7 Select Playback on the camera, this can be done by either rotating a dial to a green triangle or simply pressing a button with the same symbol.

8 Once your videos or stills are playing you need to select the correct AV channel on your TV. If you can't immediately see the output from the camera, try and be patient as sometimes the TV can take a second or two to display the picture.

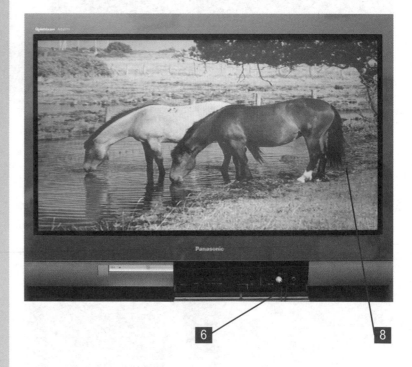

## Timesaver tip

When trying to configure your TV to playback video or stills, try and take note of the image on your digital camera's screen – this will make it easier to identify the correct image on the TV.

**9** Some cameras simply repeat the display on the back of the camera on the TV, which sounds okay in principle but can mean your photos are obscured by intrusive camera icons, such as the flash symbol or the number of photos remaining. If your camera has it, try pressing the DISP button or an icon with two vertical lines with a rounded square between them, this will toggle the way the display is laid out.

**10** To record your videos on to DVD or VHS you need to unplug the connectors from the TV and connect them directly to your recorder.

**11** Select your normal channel on the TV to watch video from your DVD/VHS recorder.

**12** On the recorder press the AV button until you find your camera's images once again. Once you have successfully found the video, put a blank disc or tape in the recorder and get ready to start recording.

**13** Finally, restart the video or slideshow on the digital camera and simultaneously start the recorder recording. Once the video is completed stop the recorder.

# Get your pictures onto your computer

## From the camera

1. First install the software that comes with the camera, this will provide the interface between the computer and the camera. It's well worth installing the bundled software as aside from just transferring the photos the software will typically also include editing and cataloguing packages.

2. You will need the USB cable normally supplied with your camera. This should be connected between the camera and the computer. If you are having trouble finding USB ports, they are normally located at the back of the PC on Windows-based computers and often on the side of Apple Mac machines.

3. Whilst transferring between the camera and the computer it is wise to have the camera fully charged or plugged into a power supply. This ensures the transfer completes successfully and there is no chance of data loss because the camera runs out of juice.

In the past getting photos from your camera was as simple as walking into your local 1-hour photo lab and asking for a set of prints, with the most taxing part being handing over the cash. The advent of digital technology has given us a lot more choices and has meant people are now taking photos that they may never get printed, and not necessarily because they're a bit rude. Now that you have viewed your photos on TV it's much easier to see the attraction of forgoing prints altogether. However, inevitably your memory card will fill up and aside from continually buying new cards you will eventually need to get your photos backed up on the PC. The following tasks will talk you through this straightforward process.

While there are numerous ways to transfer images from your camera to your home computer there are two principal methods.

## Important !

When installing the software, don't connect the camera until the software prompts you to do so, getting this in the wrong order can incorrectly configure the software.

**5**

# Get your pictures onto your computer (cont.)

**1**

---

**4** Next, set the camera in playback by selecting the green triangle on the mode dial or simply pressing the Playback button.

**5** If you have correctly installed the software the computer should automatically react to the camera and will either automatically retrieve the images and video or will at least prompt you on what course of action to take.

**6** Once you have verified the images are safely on to the computer you can delete them from the memory card.

## Jargon buster

**CCD** – Charged Couple Device forms the basis of most modern digital cameras. The alternative to the technology is known as CMOS or Complementary Metal Oxide Semiconductor. Historically the CMOS technology was used for low-cost cameras as the technology was inferior to CCD but cost less to manufacture, however, now the two technologies offer identical results at similar costs.

# Install and use a card reader

Using the camera to transfer images is not without its disadvantages, first, you can't use the camera while it's transferring, it's a drain on the batteries and it's often a lot slower than a dedicated USB card reader.

1. If the card reader comes with any software this should be installed first, this package will automate much of the transfer, it may also provide a cataloguing package. If your card reader didn't come with software don't panic, the latest operating systems can incorporate card readers without additional software.

2. Simply plug the card reader into an available USB slot, preferably a USB 2.0 high speed socket. On Windows XP-based systems this will add a series of new drive letters under the icon My Computer.

3. You can now remove the memory card from your camera – this can be located in the battery compartment or it may have its own cover elsewhere. To remove Secure Digital, Memory Stick, Memory Stick Duo and XD Picture Card you must first press the memory in, this will cause it to spring out and it can then be removed. With Compact Flash cards you will find a button next to the slot which must be pushed, this ejects the card and allows it to be pulled out.

Finally with SmartMedia it can normally be pulled out. However if you are in any doubt consult your camera manual.

4 Next insert the memory into the corresponding slot on the card reader. Ensure you do this the correct way. Remember, there should be no need to force the memory in.

5 The installed card reader package should react and request that you start transferring the images to a directory of your choosing.

6 If it fails to react, one of the new drive letters will change its name, taking on the name of your memory card or camera. To check this in Windows XP, double-click on My Computer.

7 To transfer the images across, double-click on the new drive letter, this should open up to reveal a new directory named DCIM.

## Important

If you have very important images try to keep a copy in several places – ideally write your images to a CD and keep them separate from the computer.

# Install and use a card reader (cont.)

**Jargon buster**

**USB** – an abbreviation of Universal Serial Bus and by far the most common way to connect a digital camera to a home computer. You can identify the presence of a USB connector by looking for its trident icon. Unlike older methods of connecting peripheral devices, USB allows for new accessories to be connected safely while the computer is still turned on. There are two current types of USB, 1.1 and 2.0. The connectors themselves are identical however the 2.0 standard is over 40x faster than its predecessor.

8 Open this directory and there will be either one or several new subdirectories, these will bear your camera's name, for example, 405CANON or 100NIKON – the additional numbers give an indication as to the number of photos taken.

9 By double-clicking on each these directories you will be able to access your images. All that remains now is to copy and paste them to your computer.

# Using the manual modes

## Introduction

While it's perfectly possible to get good holiday snaps and passable party pictures by relying on your camera's automatic modes, capturing truly memorable photos needs a little more investment from the photographer. In this chapter, we aim to show you what's possible by using the myriad of options any modern digital camera offers. Read on if you've ever wondered how professional photographers create beautiful images with one aspect of a photo razor sharp and the paraphernalia in the background attractively blurred. Maybe you're just perplexed with ISO or F numbers and how on earth they relate to your photos. This chapter has all the answers and through the sequence of tasks will give you a chance to incorporate new techniques into you photographic practice.

## What you'll do

Use the camera's scene modes

Use aperture priority

Use shutter priority

Make the most of manual mode

Select an ISO speed

Understand when to use spot, centre and matrix metering

Use exposure compensation

Use flash compensation

## Use the camera's scene modes

Before we delve into the more manual options, we shouldn't overlook the ever-expanding range of scene modes. Scene modes are preset configurations designed to make your life easier, taking the grey matter out of getting a perfect exposure. Need to photograph fireworks? No worries, your camera has that covered. Need to get some snapshots of a child's birthday party? It's in there too. In fact the sheer wealth of scene modes available in most modern cameras is perhaps the biggest reason why most people find them a little inaccessible. In this task we will look at some of the most widely available modes, Portrait, Landscape and Night to understand the effect these scene modes have on your images.

### Portrait mode

As it's the most commonly used mode we will start with Portrait.

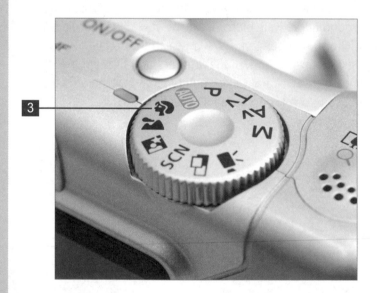

**1** If your camera has a dial to select modes, turn the dial to the picture of a bust or silhouette of a head. If you can't find the icon or don't have a dial you may need to select or press Scene – occasionally this is represented as SCN.

**2** Once in Scene mode the camera will appear to function as normal, save for a small icon in one corner showing the current scene mode.

**3** For those cameras without a dial you must now press Menu to access the available modes. Once again look for the symbol representing a head. Ensure the Portrait mode is highlighted and press OK.

## Jargon buster

**Scene modes** – achieving the best exposure settings for any given situation can be difficult. Digital cameras include numerous scene modes which take the guesswork out of configuring the camera. For example, when taking portraits a narrow depth of field is generally preferable as it draw attention to the model rather than the periphery. By selecting portrait mode the camera elects to use the largest available aperture.

## Timesaver tip

When using the red eye reduction, warn your subjects there will be multiple flashes, as people often move away after the first burst and ruin the image.

# ◀ Use the camera's scene modes (cont.)

**4** Using what you have learnt about flash photography select the appropriate mode. Typically auto with red eye reduction is best for indoor images.

**5** Now you are ready to compose your portrait, start by moving the focus point over your subject and half pressing the shutter release. Then with the button still half depressed move the camera to get the composition you prefer.

**6** Once you are satisfied with the image, and your sitter has a suitable expression then gently squeeze the shutter release to take your picture.

# Use the camera's scene modes (cont.) ▶

 Turn on the camera and if it has a dial, select the landscape mode this will be represented by a miniature mountain range. Not all cameras offer a mode dial and if you can't find the icon or don't have a dial, select or press Scene or SCN.

**2** Once in Scene mode the camera will appear to function as normal, apart from a small icon in one corner showing the current scene mode. If you have completed the previous section this will be a head.

**3** For those cameras without a dial you must now press Menu to access the available modes. Once again look for the symbol representing a mountain range. Ensure the landscape mode is highlighted and press OK.

**4** While it is possible to use a flash for landscape photography typically it is best to disable the flash before taking a daytime shot.

## Landscape mode

Another popular scene mode especially when on holiday, is the landscape mode.

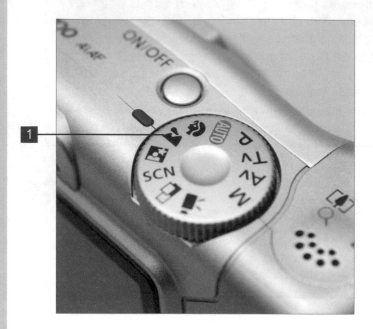

## Did you know?

On a sunny day most cameras are capable of shutter speeds in excess of one thousandth of a second. However despite these terrific speeds most professional photographers still recommended using a tripod to get the best possible image. If you don't have a tripod you can get great results using your camera's self-timer on a wall.

## ◄ Use the camera's scene modes (cont.)

**2**

5 With everything correctly configured you are ready to take your photo: half press the shutter release to allow the camera to focus and with the button held, make small adjustments to the camera's position until you are happy with the composition.

6 Once the camera is focused, gently squeeze the shutter release to capture your photo.

# Use the camera's scene modes (cont.)

## Night mode

At some time we've all looked out over the ocean or cityscape at night and felt compelled to take a picture, but prints often fall very far short of the original. Your digital camera has the solution and this section will teach you how to capitalize on its night mode.

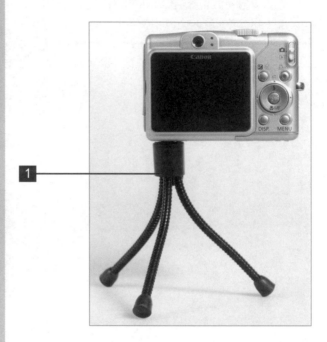

**1** Ideally when taking photos at night you should use a tripod, the longer exposure times mean that there is quite likely to be camera shake, which will soften or even blur the final image.

**2** If you are using a tripod locate the tripod's screw thread into the matching screw mount on the bottom of the camera. This is a standard size on digital cameras and should always fit. Screw the camera in place until it is secure.

**3** Turn the camera on and if it has a dial, select the night mode. This will be represented by a crescent moon or a white on black figure perhaps accompanied by a star. If you can't find the icon or don't have a dial, select or press Scene or SCN.

**4** For those cameras without a dial, you must now press Menu to access the available modes. Highlight the night mode symbol and press OK.

**5** Select your desired flash mode. For portraits the flash with red eye reduction is

2

preferable and for landscape images generally the flash should be disabled. However, feel free to experiment.

6 Whether you are using a tripod or not it's worth using the self-timer as this eliminates the possibility of any camera shake introduced when you press the shutter release.

7 Push the four-way controller towards the stop watch symbol. This should bring up a menu on the camera display allowing you to toggle the timer on and off. Some cameras even have timer variables such as 2 or 10 seconds.

8 With everything correctly configured you are ready to take your photo, half-press the shutter release to allow the camera to focus and with the button held, make small adjustments to the camera's position until you are happy with the composition.

9 Once the camera is focused, gently squeeze the shutter release. This will start the timer's countdown and once completed, capture your photo.

# Use aperture priority

Just like the iris of your eye, your camera's aperture controls how much light is allowed to fall on to its sensor but just as important, it also controls how much of the image is in focus. In this task we will try changing the aperture value and gain an understanding of how that affects exposure and the images we can create. The standard measurement of apertures is shown in F stops, which typically range through 2, 2.8, 4, 5.6, 8, 11, 16 and 22. As if to confuse matters the higher value, the smaller the aperture. By altering the size of the aperture it's possible to increase or decrease the amount of the image that is in focus. This is known as the depth of field and allows for a great deal of creative control.

1 Not all compact cameras provide the option to control the manual settings. If your camera has a dial to select modes, turn the dial to the letter A. If you can't find it or don't have a dial you may need to select or press M.

2 For those cameras without a dial you must now press Menu to access the available modes. Once again look for the letter A or M. Once this is highlighted press OK.

3 Selecting A or M will put you into the manual shooting mode.

4 In the previous scene modes, the camera was configured to achieve the best results depending on the type of shot selected, here we have the choice to alter the camera's aperture values and rely on its built-in metering to adjust the shutter speed to our choices.

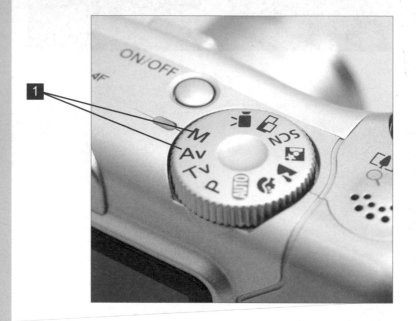

## Jargon buster

**TTL-metering** – the term TTL stands for Through the Lens, and is usually used in the context of how cameras interact with a flash. Using TTL, the required exposure is measured from the light travelling directly down the cameras lens. When firing a flash, the sensors in the camera can then adjust the flash's output ensuring the exposure is as accurate as possible.

## Jargon buster

**Aperture** – in simple terms the aperture is the hole through which the light travels. In photography, aperture is used to describe the diameter of the diaphragm, which controls the access of light. Using a larger opening more light comes in creating an image with a shallower depth of field, with a smaller opening the camera takes longer to get the same light, but the image has a larger depth of field.

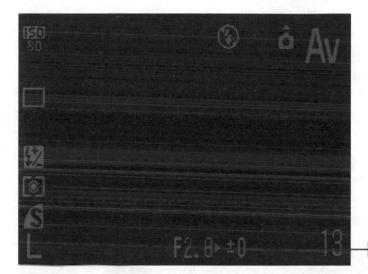

**5** On the LCD screen there will be an F with a series of numbers next to it. Typically by pushing up or down on the four-way control or rotating a wheel, it is possible to alter this number.

**6** To produce similar effects to that of portrait mode, keep pressing the number until it is as low as it will go. For example F3.5 or F2.8.

**7** If you are shooting indoors remember to turn on the auto flash with red eye reduction.

## Jargon buster

**LCD** – an abbreviation of Liquid Crystal Display, it describes the technology used in most modern digital cameras to provide a real-time view-and-review screen. LCD is often used as a generic term and manufacturers have many new technologies such as OLED. These more advanced display technologies promise to provide better battery life whilst still being big enough and bright enough to use in direct sunlight.

## Use aperture priority (cont.)

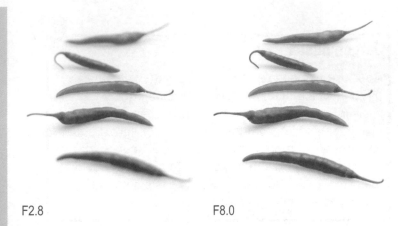

F2.8                                            F8.0

8  Now that you are ready to compose your portrait, move the focus point over your subject and half press the shutter release. Then with the button still half depressed move the camera to get the composition you prefer.

9  When you're ready squeeze the shutter release to take your photo.

10  Try repeating this task with different aperture values. You will notice that this has an impact on how much of the image is in focus. Using higher numbers can produce the same effect as a landscape photo, with much of the image sharp.

### Timesaver tip

**Reflector**

When taking portrait shots in strong directional light some aspects of the subject's face can be in shadow, by carrying a fold-out reflector you can shine light into the darker areas.

### Jargon buster

**Reflector** – typically a fold-out disk or panel with a reflective white, silver or gold surface. Reflectors are normally used in portrait or studio work to direct light in order to lighten any darker aspects of the image.

Before

After

There can't be anyone who has used a camera and not had a blurred photo or two back from the photo labs at some point, whether the whole image was blurred or simply one moving element. If you didn't intend it, the effect normally ruins the snapshot. By learning what to expect from differing shutter speeds and more specifically, how to control the speed chosen by your camera you can either ensure you don't get any more bothersome blur or take the bull by the horns and deliberately add it to try some new creative exposures. As with many aspects of photography there are no real rules but in this task we'll look at some guidelines that should improve your images.

### Jargon buster

**Shutter priority** – progressing beyond using automatic shutter priority allows you to specify exactly what shutter speed you require to create your exposure, however in order to achieve this the camera automatically adjusts the aperture value to ensure the exposure is still correct.

◄ ## Use shutter priority

1 First, we need to select shutter priority. Turn the mode dial to S for shutter priority, if you have a Canon camera this will be under Tv for time value. If you can't find S or don't have a dial you may need to select or press S.

2 For those cameras without a dial you must now press Menu to access the available modes. Once again look for the letter S or M. Once this is highlighted, press OK. Selecting S or M will put you into the manual-shooting mode.

3 In our first experiment with shutter priority we will try and freeze some movement as sharp as possible.

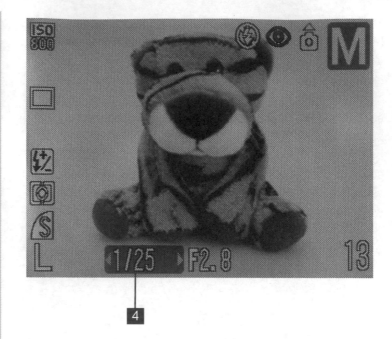

4

**4** Next to the F number from the previous task you will see another number which looks like a fraction, for example 1/25. As with the aperture value, this can be changed by pushing up or down on the four-way control, or in some cases by turning a selector wheel.

**5** To freeze a moving subject you should adjust this number until it reaches 1/250, this means the shutter will be open for only a 250th of a second. If the F number next to this changes to red it is an indication that there isn't enough light for this speed.

**Jargon buster**

**Shutter speed** – cameras use a shutter that opens to allow light in to create an exposure, the speed at which it opens and closes is referred to as shutter speed. Shutter speed is normally measured in fractions of a second, but longer exposures can be several seconds or more.

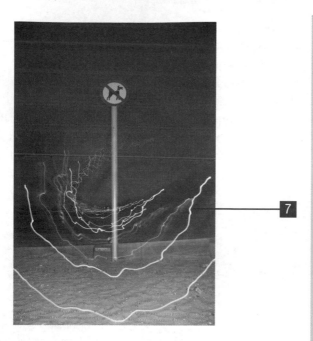

**6** Now you are ready to compose your photo, quickly move the focus point over your subject and half press the shutter release. Once it confirms focus, squeeze the shutter release to take your photo.

**7** Repeat this task with different shutter speeds and you'll notice the subject begins to develop a motion blur. Try using slower shutter speeds in conjunction with a flash – this can create some interesting effects.

2

## Jargon buster

**Burst mode** – when photographing sport, getting the timing of your shots right can be the difference between an empty frame or a race car crossing the line, this is where burst mode or continuous shooting comes in. Burst mode takes a series of photos in rapid succession giving you more chance to get the crucial moment, often cameras quote a FPS or frames per second.

# Make the most of manual mode

Switching your camera to M seems a long way from the safety of automatic, but mastering the manual mode can be a great deal of fun and allows you to really get hands-on, to try out new ideas and experiment with different exposure settings. However, while it is true that manual mode literally hands back control of your exposures to you, the drawback is it also gives you the freedom to really screw up. Take heart though, after all, getting it all wrong and trying again is pretty much one of the main benefits of digital, just don't go wading into attempting to photograph a wedding using manual – even many of the professionals don't try that.

**1** First turn the dial to M to select Manual. This mode combines adjustments of the shutter and aperture to give you complete control over your exposure including the ability to choose your own white balance.

**2** For those cameras without a dial, you must now press Menu to access the available modes. Look for the letter M or Manual, once this is highlighted, press OK to activate manual shooting mode.

**3** Try photographing items in and around your home as this will familiarize you with the camera's metering system and just how much light is required to get a good photo.

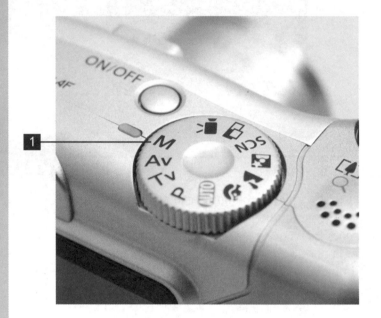

## Jargon buster

**White balance** – digital cameras come equipped with numerous preset white balances, including tungsten, daylight, cloudy and so on. These settings are designed to compensate for the differing wavelengths of light coming from the different light sources their names represent. For example, photographing under a fluorescent strip light without selecting the correct white balance, is likely to give the image a blue appearance.

## Make the most of manual mode (cont.)

### For your information

To help you find the right exposure the camera displays how much over or under exposed the image will be by using an EV or exposure value scale. Each full EV stands for one stop too much or too little light. Most cameras display the EV as a number which can change in increments of thirds, for example -0.3 EV this would mean the camera isn't getting quite enough light and perhaps a slower shutter speed would be appropriate.

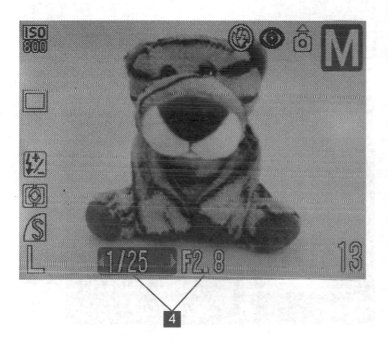

2

**4** In our previous tasks we tried altering the aperture and shutter independently, in this task the same controls can be used to adjust both values together. However take note, where previously the two values automatically adjusted to compensate for your choice of shutter speed or aperture value, now it's up to you to adjust the other value and balance the equation. For example, if you change from F5.6 to F8 that will let in half as much light and so require twice the exposure time, specifically a change from 1/60 to 1/30.

**5** To capture a successful photo you must set up your desired composition then tap the shutter release to take a meter reading. This will provide you with measurement of how much light is required.

# Make the most of manual mode (cont.)

6 Next adjust both the aperture and shutter speed to the correct values to create a well exposed photo. You are now ready to capture your photo, quickly move the focus point over your subject and half press the shutter release.

7 Once it confirms focus gently squeeze the shutter release to take your photo.

## For your information

Digital cameras have an additional trick up their sleeves to check the available light, known as the histogram. Histograms provide an accurate breakdown of the light and dark pixels in your picture. Along the horizontal line the histogram represents every available tone from jet black valued at 0 to brilliant white valued at 255. Where the peaks are indicates how light or dark the image is. The height of these peaks shows you how many pixels have this particular shade or colour. While there isn't a right or wrong way for the histogram to look, for most snap shots you should aim to have the peaks toward the centre of the image, thereby avoiding under or over-exposure. *

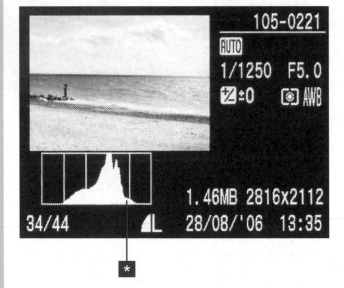

If you've ever bought a roll of 35mm film the letters ISO maybe familiar to you, ISO stands for International Standards Organization and in relation to film photography its used to represent the film's reactivity to light. The higher the number of a film, the faster it would absorb the image, the trade-off however was that this faster film would normally appear grainier and would typically record less fine detail.

Move on to digital cameras and obviously the film is no longer part of the equation, however digital cameras still have ISO numbers allowing us to understand how they will perform in different lighting. Digital cameras can mimic the reactivity of faster film by amplifying the signal received by the light-sensitive sensor. However, just like amplifiers on a stereo this can introduce noise. With a stereo this has the effect of distorting the sound or adding hissing but in digital photography this adds a visible fizz to the image made up of unwanted coloured dots. In this task we experiment with the ISO speeds and learn what our camera is capable of.

## Select an ISO speed

**1** The first task is to find the camera's ISO control, which differs for almost every camera. However typically it is either clearly labelled as ISO on the camera's body or accessible via the Menu command. In some cases the ISO control will be labelled as Sensitivity.

**2** Depending on the configuration of your camera either rotate the mode dial or press the appropriate button to open the ISO menu.

**3** You will now be presented with the list of available ISO settings as well as an automatic setting. As tempting as it may be to leave the camera on the Auto setting, typically it doesn't offer the complete range of the camera's capabilities. Indeed knowing how to switch ISO modes can allow you much more creative flexibility.

2

## Select an ISO speed (cont.)

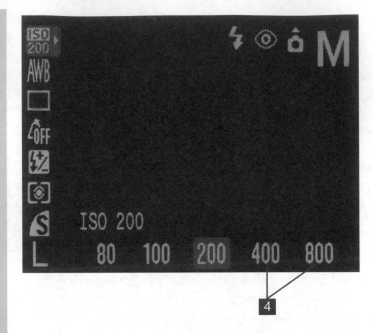

**4** Now that we have found the ISO menu the first task is to select the highest value, this will normally be either, 400, 800 or 1600. While there are other values available these are amongst the most common options. After choosing the highest available value, confirm the choice by pressing OK or in the case of Olympus cameras pushing the navigation pad to the right.

**5** The camera is now at its most sensitive, making it easier to shoot photos indoors without blurring, the downside to this mode is the images are going to have a grainier or noisier quality to them. This will be hard to see on the small camera display, but it's there.

**6** After experimenting with the higher sensitivity we will set the camera to its midway point. Open the ISO menu back up again and this time select the ISO 200 speed. While this won't necessarily be the middle speed available it should provide a reasonable average.

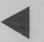
**7** Once set at 200, your camera will behave as normal, giving well-exposed images in typical daylight scenes and good indoor photos when assisted by the built-in flash. More important, your photos should exhibit almost no noise or grain giving them a smooth detailed quality. What we need to play with next is the camera's lowest speed – this mode can be suitable for creating longer exposures.

**8** Open the ISO menu again for the last time in this task and select the lowest value available, 50, 64 or 100 are typically the lowest speeds found on standard compact cameras. As least-reactive speeds available they may leave you scratching your head as to their practical application. However should you want to use a long exposure or large aperture you may find the higher ISO values simple can't cope.

**9** Try taking some images at night with the lower ISO setting and compare the results with higher values, the contrast in image noise should underline the value of these last group of ISO values.

**Using the manual modes 45**

## Understand when to use spot, centre and matrix metering

▶

Now that we have learnt how to exert more control over the way our images are constructed, it's time to take a more detailed look at the way our cameras actually see things. If you'll forgive the tired analogy, the camera works much like the human eye. The iris of an eye can expand or contract depending on the amount of light available and, just as important, what bit of the world around you your brain chooses to focus on. Cameras don't have the benefit of your brain to control the way they pick out details, what they do have however, is advanced ways of gauging or metering the light. Most cameras depend on a matrix of sensors to measure an exposure which balances as much of the image as possible, this is known as matrix or evaluative metering. Some cameras offer alternatives which allow for more creativity, such as centre-weighted or even Spot metering. These concentrate on the middle portion or a tiny circle in the centre of the scene respectively. In this task we will look at the effect of using differing metering modes.

1 For this task put the camera into auto mode and choose a subject that is either much darker or brighter than the surrounding area – for example taking a portrait with the window behind your subject or a hallway looking out to a bright exterior.

2 This highly contrasting scene will present a challenge for the camera's average-based metering, so try taking a couple of test shots focusing on the chosen subject. The camera will concentrate on the correctly exposing the vast majority of the image, which will result in massively under or over-exposing the subject itself.

3 This is where a bad workman would be blaming, if not bludgeoning, his tools! However, we know better and now we will select the centre-weighted metering mode. First, if available, rotate the mode dial to put the camera into Program AE or P mode.

1

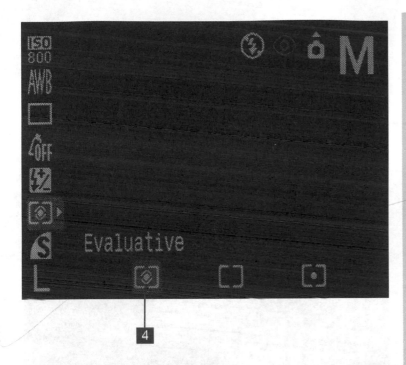

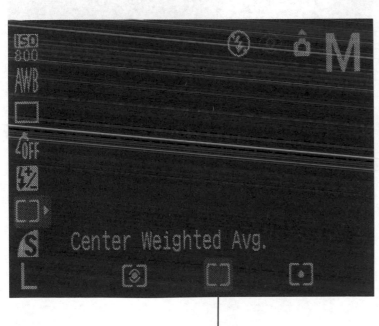

**4** Next, press the Menu button, which should give you access to the shooting menu. Depending on the camera system you will either find the metering mode clearly labelled or you should look for a box with a dot in it enclosed by brackets above and below.

**5** Press the metering icon or menu, this will give you access to the array of metering modes. These will either be presented as a list or you may have to press the same button repeatedly to toggle between the numerous options. For centre-weighted on a Nikon you should look for the same square box with a dot in it and brackets above and below, on a Canon the box should be empty.

## Understand when to use spot, centre and matrix metering (cont.)

6 Once you have identified and selected the correct mode press OK to return to the shooting mode. Try taking some more shots of the same subject – you may be able to notice a slight shift towards correct exposure of the subject rather than the background. This is because the metering information for everything outside the centre portion is discarded, allowing you to be more selective.

7 Finally there is a spot metering mode. Not all cameras have this option but if you return to the metering mode it is represented by a square with just a dot in the centre. This mode typically only uses metering information from around 3.5% to 5% of the centre of the scene. This mode will correctly expose just the tiny bit in the centre of the image, making it ideal for shooting subjects in a shaft of light or strongly backlit without resorting to a flash.

**Jargon buster**

**Auto-bracketing** – judging the correct exposure in situations with both very bright and very dark elements can be extremely challenging, and if this isn't somewhere you're likely to return to this is where auto bracketing comes in. Bracketing takes a series of shots – usually between 3 and 5 – with exposures slightly above and below the suggested metered exposure.

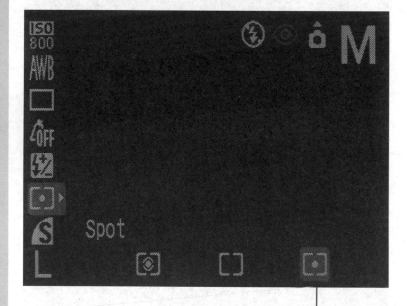

8

## Understand when to use spot, centre and matrix metering (cont.)

8 Try shooting the same scene in each of these modes and experiment with the spot metering mode. It's possible to create radically different exposures with just a slight shift in the position of the camera.

2

# Use exposure compensation

In a perfect world, the advances in digital cameras would ensure we got a correct exposure every time. However while it's true modern cameras do take a lot of the guesswork out of photography there are still many occasions where you'll have to take over to guarantee you get the image you want. This is where exposure compensation comes into play. It can help prevent your clever camera ruining your photos. Most modern cameras allow you to adjust the exposure in steps of either a half or a third of an EV or exposure value – this allows you to darken or lighten the way the camera captures the image. Anyone familiar with Adobe Photoshop or a similar photo editing package will no doubt be thinking how it is possible to adjust the brightness and contrast later. Which is true, although it's good practice to make any adjustments while you are taking the photo as this produces the best image quality, editing later can introduce unwanted noise to the image. For this task we will look at two common situations in which exposure compensation is extremely useful.

## Shooting a wedding dress

Weddings can be fraught with stress at the best of times but when you have the added pressure of being selected as the official photographer you need to ensure you get it right. Remember there's no law against practising. If you have access to a wedding dress or can at least rent one it gives you a fantastic opportunity to familiarize yourself with the inherent problems of photographing a brilliant white dress on a bright day. It might seem like cheating but if you want to set out as a wedding photographer you should know that many budding photographers rely on friends or family to build up their initial portfolio. This task will give you some handy hints to improving your wedding photos.

## Did you know?

### Blooming

A digital camera sensor is made up of millions of tiny receptors – think of them as miniature wells. Light pouring in is collected in these wells. If one bright area saturates its well, sometimes the excess spills over into neighbouring wells. This overflow then artificially increases the brightness of the surrounding areas. To lessen or avoid this 'blooming', modern digital cameras using gating systems.

## Use exposure compensation (cont.)

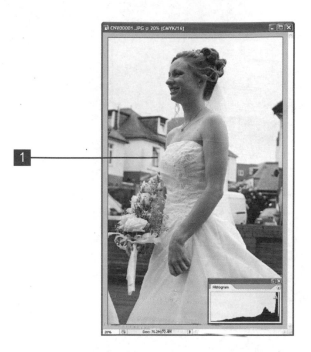

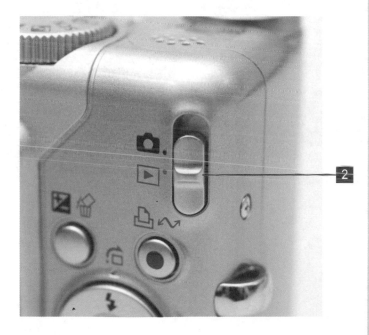

**1** Once you have your suitably attired model, set up your ideal image and take a sample photograph. This image will briefly play back on the camera's display, however, we are going to need to see it for a little longer.

**2** Switch the camera to playback by rotating the mode dial or pressing the playback button then find the sample image. The image is likely to look perfect on the camera's small display. However it's extremely deceptive and you should never trust your camera's display for anything more than checking the composition.

**3** If your camera features a histogram this is where it becomes extremely useful. You can access the histogram by repeatedly pressing the display button until it toggles through the various display modes before finding the histogram reading.

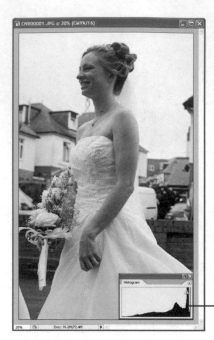

**4** Typically the histogram is split into five segments representing from left to right, very dark (shadow detail), dark, mid (18% grey), light, and finally highlights. While there is no such thing as a bad histogram reading it's perfectly plausible to read the curve and re-shoot accordingly.

**5** Closely examine the reading – when shooting a wedding dress there should be a peak in the fifth portion of the reading. However if the histogram shows the curve peaking in the fourth section perhaps the image could use additional exposure, whereas if it's way out to the far right it's likely to be overexposed.

**6** Switch the camera back into capture mode and look for the exposure compensation symbol, this may be on the camera's exterior or within its menu. You can recognize the symbol as a diagonally crossed square with a plus and minus symbol on either side of the line.

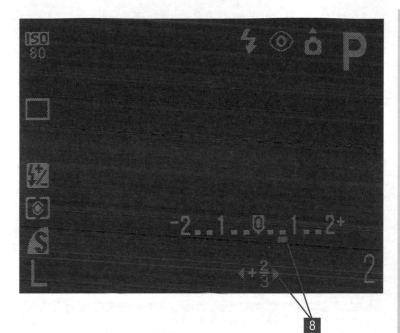

## Use exposure compensation (cont.)

**7** Once you select the exposure compensation symbol a horizontal line will appear next to it along with a number. This number will start at 0.0 and can be adjusted by either rotating the camera's control dial or pressing up or down on the four-way navigation pad. Typically the value will go up or down in 0.5 or 0.3 jumps, negative values will darken the exposure and positive values can be used to brighten it up.

**8** Depending on the results of the test shot's histogram, increase or reduce the exposure value by a third of a stop (0.3), retake the photo and check the histogram reading again. If you reduced the value you should notice the peaks move slightly to the left, pulling the curve away from the extreme right and curing the overexposure. If you increased the exposure the peak should have travelled to the right and into the fifth portion of the histogram.

**9** Try experimenting with the exposure compensation – it should give you a good idea how your camera is likely to perform in differing situations.

# Use exposure compensation (cont.)

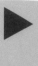

1 Step one is to take a well-deserved holiday, once abroad we can tend to the task of photographing beaches or snow. Whether you go on a winter break or worship the sun, the same thought process can be applied. Try taking some sample shots. Don't worry if they disappear before you get a chance to closely examine them.

2 Switch the camera to playback by rotating the mode dial or pressing the Playback button to find the sample image. The image is likely to look perfect on the camera's small display, again don't trust this, just check the composition.

3 As with the previous task we are going to access the camera's histogram, which you can do by repeatedly pressing the Display button until it toggles into the histogram display mode.

## Beach or snow holidays

It's a common complaint that photos taken at the beach or on the slopes often come back looking murky and lifeless. This is because the metering system in every camera tries to produce an averaged version of what it sees, ideally trying to create an 18% grey version of the world around it. In most situations this technique achieves a good even exposure. However when the environment really has dazzling sands or crisp, brilliantly white snow your camera gets confused and tries to correct for what it thinks is overexposure. This task will help you correct for this effect.

## Jargon buster

**Backlit** – if you photograph someone with their back to a bright light source, it can fool your camera into capturing your sitter as a silhouette. This is caused by the camera trying to weigh up the darkness of your subject and the brilliance of the background. Using a fill-in flash can help to balance the image and ensure the subject is correctly captured.

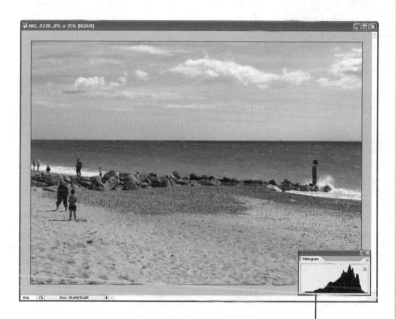

4

**4** The test images are likely to show a series of varying sized peaks but look specifically for a tall peak rising in the fourth segment of the histogram. This represents the sand or snow. Ideally this peak should be moved into the fifth segment so that the photo looks correctly exposed.

**5** Switch the camera back into capture mode and look for the exposure compensation symbol, this may be on the camera's exterior or within its menu. You can recognize the symbol as a diagonally crossed square with a plus and minus symbol on either side of the line.

**6** Once you select the exposure compensation symbol a horizontal line will appear next to it along with a number. This number will start at 0.0. Try increasing the exposure value by a third of a stop (0.3), retake the photo and check the histogram reading again for this new photo. You should notice the peaks move slightly to the right – this will have the effect of brightening up the image and making the colours more pleasing.

**2**

**Using the manual modes 55**

# Use flash compensation

Now that we understand about exposure compensation it's time to look at flash compensation. Predictably the two features have a lot in common, and both allow you to adjust the way you record your photo at the time of capture. Obviously flash compensation only comes into play when using the camera's flash – by using the compensation adjustment it's possible to increase or decrease the power of the flash. For example, if you were taking close portraits in a poorly-lit room some compact cameras can't judge the exposure correctly and leave your subjects looking as though they've had their features blasted into a brilliant oblivion by the overpowered flash. This task will teach you how to adjust the power of your flash, enabling you to control an unruly flash or add more light if you think your shots need them.

**See also**

'Get the best from your built-in flash'.

1 You can practise either with another willing sitter or simply with a still life subject. However it's important you get in close. For the purpose of this task try and get between 50 and 100cm away from your subject.

2 Half press the shutter release and ensure you are able to focus at this close distance. If the camera fails to focus take a step back until it locks on.

3 After confirming focus ensure the camera is set to force the flash to fire.

4 Take a shot with the camera and review this test shot by switching the camera into playback mode.

5 It's likely the image will be very obviously overexposed. However if your camera features a histogram it would be wise to access this as confirmation. You can access the histogram by repeatedly pressing the display button until it arrives at the histogram reading.

## Did you know?

### Fringing

What is sometimes referred to as purple fringing has much in common with chromatic aberration. Both effects are created by the differing wavelengths of light not being sufficiently corrected for. Fringing however, occurs at the camera's microlenses. On some sensors, tiny lenses are added to help to funnel the light into the small receptors.

## Jargon buster

**Pixel** – short for picture element, it represents the smallest part of an image. Digital cameras refer to millions of pixels as Megapixels.

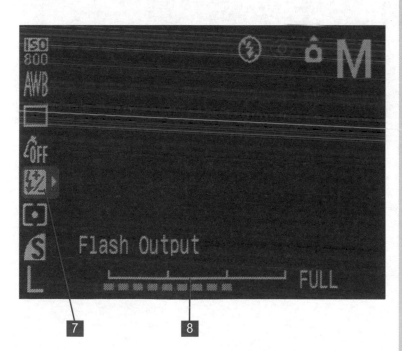

# Use flash compensation (cont.)

2

6  Typically the histogram is split into five segments representing from left to right, very dark (shadow detail), dark, mid (18% grey), light, and finally highlights. If the histogram shows the curve peaking in the fifth segment it's likely to be overexposed.

7  To correct overexposure we need to access the flash compensation, the symbol has a diagonally crossed square with a plus and minus symbol on either side of the line much like the exposure compensation icon – with the addition of a lightning strike next to it.

8  Once you have selected this option from the camera menu, you can then adjust its value. This will start at 0.0 and can be adjusted by either rotating the camera's control dial or pressing up and down on the four-way navigation pad. Typically, the value will go up or down in 0.5 or 0.3 jumps – negative values will reduce the power of the flash and positive values increase it.

# Use flash compensation (cont.)

9

**9** If your test image was overexposed, try reducing the power of the flash value by a third of a stop (0.3). Then retake the photo and check the histogram reading again. From the camera screen you should see the subject is less harshly lit, the histogram should show the peaks moving slightly to the left, pulling the curve away from the extreme right and curing the overexposure.

**10** Try experimenting with the flash compensation to learn how you camera handles both close and distant subjects.

### Did you know?

#### Chromatic aberration

This term simply means the colours on the print are out of alignment. This is due to the fact that different colours of light have different wavelengths. These wavelengths are bent by the elements of a camera lens at slightly different angles and unless the lens has additional correcting elements, the print will show slight red and blue edges on high-contrast objects.

# Advanced techniques to improve your shots

## Introduction

Armed with the newfound knowledge of our camera's array of different exposure settings, we move on to a series of practical exercises that employ this fluency and allow us to create a range of photographic effects. To start with this chapter will cover techniques created by the camera, however we also begin to dabble with photo editing packages, such as the industry standard Adobe Photoshop Creative Suite 2.

## What you'll do

**Think in print sizes**

**Get great portrait and group shots**

**Photograph children**

**Capture motion blur**

**Create a zoom blur**

**Shoot at night**

**Take long exposures**

**Paint with light**

**Hit a moving target with continuous focus**

**Experiment with digital filters**

**Use macro photography**

**Understand white balance**

**Use preset white balances**

**Use the histogram**

**Shoot in RAW**

# Think in print sizes ▶

The key to creating successful photos is visualize, at the time of capture, the final print. If you give more consideration to your objective while setting the photo up, you're far more likely to arrive at the desired image. What this means in practice is simple exercises such as giving consideration to the size of the print you are likely to want. If you want a photo for a square frame, you need to visualize this as it will obviously preclude any images which spread across the frame all the way from left to right. If you always have your prints at 6x4 this is particularly important as digital prints aren't ideally suited to this size and typically lose some of both the top and the bottom of the image. You could simply print your photos at 7x5 but they won't fit in the album any more. In this task we will take several photos using the camera's frame differently each time – you can apply this task to any images, groups or still life.

1. First you need to arrange your scene to achieve the composition you are after – for this first section we are looking to capture a 10x8 image. With groups don't be afraid to give people direction but remember to be friendly and clear.

2. Step back from your scene and quickly check that the light is appropriate – this is especially important for groups. Make sure everyone's face is unobstructed and isn't shadowed by any of the other group members.

1

## Timesaver tip

A 6x4 print is narrower than 10x8, when visualizing your composition you should ensure your sitters don't have their heads or feet too close to the top or bottom as they will be cropped off.

**3** Now that you have your image, once again visualize the squarer format of a 10x8 photo. With these constraints in mind, use your camera's zoom, or alter your position or even the group to frame your subjects – but remember to leave around 10% at either side of the image unused.

**4** Once you are satisfied with the composition take at least two photos from the same position. With two photos from the same position you have a better likelihood of getting everyone's eyes open, and if someone blinked you can copy their eyes from the other image.

**5** Repeat this exercise but this time we will try to compose the photo to be printed at 6x4.

3

Portraiture is perhaps the most popular area of photography and like any other discipline within photography it has its own skills and techniques that can be invaluable to any photographer starting out. In this section we will look at the best way to photograph individual sitters and techniques for improving your group shots, but remember as with most of the rules in photography they are there for guidance and sometimes breaking the rules makes for better photographs. Tackling portraiture first we are going to look at different postures and how they affect the image – predictably you need a willing volunteer for this task.

## Individual portraits

1 Find a suitable space in your house where you have either a large window for natural light or can use an adjustable lamp.

2 Before taking any photos remember that the focus of your images should be the model's eyes. While they don't necessarily need to be looking at you it's generally accepted that they should be the point of focus.

3 Set the camera into portrait mode or if you prefer try using aperture priority with a wider aperture such as F2.8 to give a shallow depth of field.

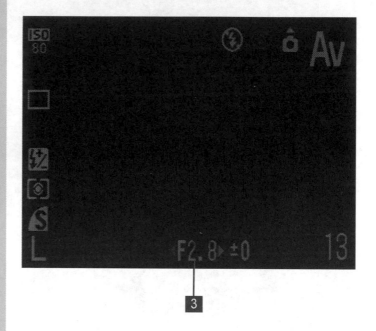

3

## Jargon buster

**Depth of field** – refers to the distance between the nearest and furthest points your camera has in focus. Adjusting the camera's aperture directly controls this area. Higher F numbers such as F22 can offer almost infinite depth of field, whereas lower F numbers such as F2.8 are more suitable for portraiture as they offer a very limited focus area.

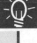

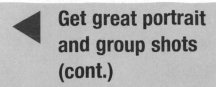
**4** Before adjusting the camera's zoom, turn your camera through 90 degrees so that the shutter release is above the lens. You should find the camera is now better suited to the upright model. Make sure you are comfortable with your grip on the camera and that you can still press the shutter release.

**5** For the first photo have your model stand with their head and shoulders square to the camera – in your mind's eye you should be trying to recreate a passport-style photo.

**6** Focus on the model's head and shoulders and try taking a photo. While your image is representative of your sitter it's unlikely that it will be very complimentary.

**7** Next have your model continue to look square at the camera but move their right foot one pace forward and lead with their right shoulder. Their shoulders should be approximately at 45 degrees to the camera. This image should be better than the first.

3

## Jargon buster

**Aperture priority** – cameras equipped with this mode allow you to select your desired aperture value, whilst automatically adjusting the shutter speed to ensure the exposure is still correct for the image. Aperture priority mode can be very useful for controlling depth of field.

## Did you know?

When photographing men it's convention for the image to be as sharp as possible. This reveals the detail in the model's face and giving them strength and character. For portraits of women the lighting is generally much softer, employing the use of a diffuser to give the final photo a more complimentary appearance.

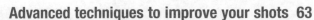

# Get great portrait and group shots (cont.)

8

8 For this photo ask your model to keep their feet and shoulders the same. They should turn their head slightly away from the camera but keeping their gaze on the camera. Ideally they should also tilt their head just a little so that their eyes aren't perfectly level. After taking this photo you should have achieved a more attractive image. Now we need to address the lighting.

9

9 While a lamp might give you the opportunity to be more creative with your lighting, natural light typically gives an attractive even light. In both eventualities you should try and avoid very dark shadows on your model's face. You can try moving your model but it's easier to use a reflector to direct some light into the darker areas, you needn't spend a fortune on professional equipment – a simple sheet of brilliant A3 card, paper or even tinfoil can be enough to reduce the contrast and give you a better photo.

## Small Group Shots

Taking good group photos is the lifeblood of any successful photographer, but directing people to achieve the shot you want doesn't come naturally to everyone and can be a daunting prospect. Ultimately, no amount of advice can replace hard-earned experience, but we can offer some words of wisdom to save you some of the worst pitfalls.

1 Before standing in front of your group check your equipment, ensuring you have sufficient space on your memory card, your batteries will last long enough and the camera isn't on an unwanted setting.

2 Once you have introduced yourself, consider the composition of your group and if necessary move your sitters around so that the image is balanced, and none of the group casts a shadow on the face of anyone else.

3 Don't overlook the environment around you – if necessary try using chairs or stairs to alter the composition.

4 Photos of posed groups often look very unnatural – this is typically because the people posing feel awkward. After all very few people actually enjoy being photographed. Try and appear relaxed and confident.

5 Once you have set up your desired image take more than one photo of each composition – in groups it can be hard to ensure no one blinks.

3

## Get great portrait and group shots (cont.)

### Large Group Shots

A large group shot can be for any reason but more often than not they are associated with a family occasion like a wedding or birthday. At any celebration it's always wise to get these larger groups shots done early, before anyone gets tired, gets to the bar, or gets even on an old score.

1 Before addressing your group, plan your shot. You must find a space that will accommodate everyone. Consider the lighting as well as the space, larger rooms can be very hard for a compact camera's flash to light successfully.

2 Next consider where you will be standing, you need to think about what your viewpoint will be. Ideally you should also find a location that gives you a vantage point where everyone will be visible. You may have seen professional photographers carrying stepladders at events such as weddings, now you know why.

3 For a large group of this nature you have to speak up, it's no good whispering away in the back, you won't get people's attention or their faces looking at you.

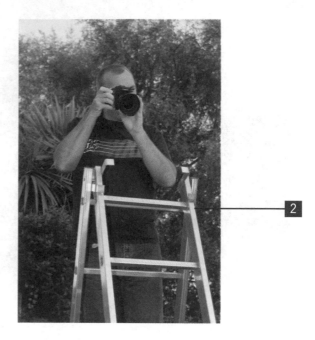

2

**Important**

When planning to photograph a wedding, you should always walk around the venue before the event, make a note of good areas for groups, considering the lighting as well as the space. Plan what images will be taken where and arrange them so the people involved in each photo can be called upon only when needed and aren't left hanging around. On the day be confident, try and use your plan but be prepared to make changes without panicking.

**4** Once you have everyone's attention get your group to countdown or say 'Cheese' – while it might seem old-fashioned it still works.

**5** Play it safe and take several images of each group, but remember not to take too long – the novelty of being photographed wears thin very quickly.

3

# Photograph children

The birth of a new child is one of the best reasons to embark on the pastime of photography. While it's unlikely that you will look too critically at photos of your newest family member we can offer you some tips to improve your photos and ensure it's a fun activity for all concerned. First, it's important you get your kids used to being photographed, so make your photos a family tradition. Children thrive on routine and it means you'll have a record of their changing appearance.

1 Check you camera has enough battery power and storage space before setting off for the day.

2 Put your camera into automatic or Program AE mode, your attention will need to be focused elsewhere so for once let the camera make most of the decisions for you.

3 It's unlikely you will get the shots you have in mind immediately so you will have to be patient, but always keep the camera at hand for quick snaps.

4 Try and make the experience fun, engage the children in games, as this is far more likely to pay off and get them relaxed and smiling. For most children they will be at their best around mid morning so try and organize it so your photography falls around this time.

5 As with a good portrait you need to keep the focus point on the child's eyes. To help achieve this, always try and shoot your photos at eye level. You might come away with sore knees but you're guaranteed to get better photos.

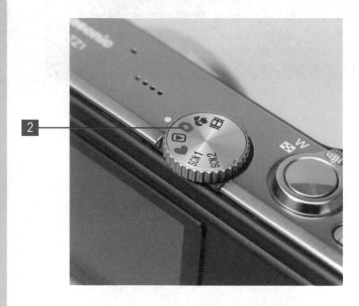

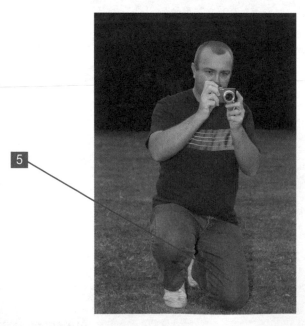

## See also

Photographing children can be a very lucrative pastime, however understandably it's not without a good deal of red tape. Turn to 'Know your rights and responsibilities' for more information.

## Jargon buster

**Digital zoom** – unlike an optical zoom lens, digital zoom doesn't use the lens to magnify the subject. Instead the camera discards some of the light hitting the sensor opting instead to use just the centre portion. This has the effect of making the image appear magnified. However, as less of the sensor is used it does have the drawback of reducing the picture quality.

## Jargon buster

**Interpolated** – on some digital cameras it is possible for the camera to produce images that offer a higher megapixel count than the sensor itself physically offers. This is achieved by using complex mathematic calculation to produce a larger image than was originally recorded, this effect is known as interpolation.

6 Don't be afraid to get in close. Once the child is comfortable you can try taking some shots of just their face – remember you don't have to have full body shots in every photo. Don't rely on your camera's digital zoom, the photos will come out grainy if you do.

7 Once you have a composition you are happy with, half press the shutter release with the child under the focus point, then with the button still depressed recompose your image with the child off centre.

8 Gently squeeze the shutter release to capture your picture, if you want to get eye contact in your photo, call your child's name just before taking the photo. By having the camera focused and ready you can capture photos with minimal lag.

9 Take lots of shots – the best poses always come when you least expect them so shoot more photos than you would normally.

10 Try taking some shots whilst your children are at play without having them pose, these candid shots can be more memorable.

3

# Capture motion blur

After the numerous tasks we have covered, detailing how to avoid blurring your images it may seem odd to see an entire section dedicated to the pursuit of adding it! However, correctly implemented blur can be an effective way of suggesting movement or speed. This task will explain how to create and utilize motion blur to allow you to experiment in your own images. This task will also introduce the idea of panning the camera in time with a moving subject, to blur out the background while keeping the subject sharp, an idea we will concentrate on more in following sections. This technique is great for covering any sort of race.

## Motion blur in natural light

1. If you're attending a race take some time to find a good location around the track, remember to keep safe.

2. Check the camera's ISO speed and set this to match the lighting conditions, for a bright day, 100 should be enough but if it is overcast try using 400.

3. Put your camera into shutter priority mode shown as Tv on Canon cameras and set the shutter speed to 1/250. Faster shutter speeds may give you sharper subjects but can also have the effect of making them look stationary.

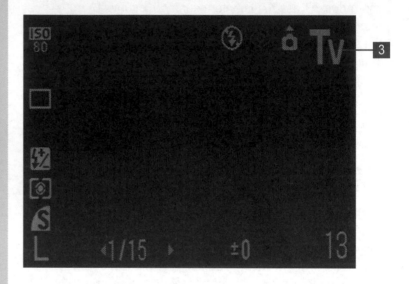

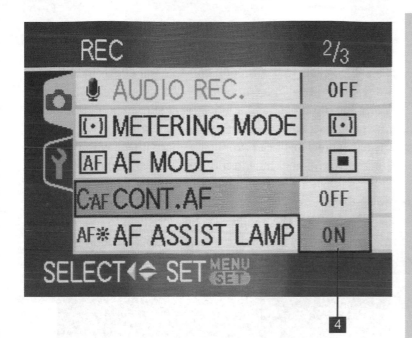

**4** If your camera has an option for continuous focus then select this option. Using this mode, the camera will continually refocus on your moving target as long as you have the shutter release half pressed. Some cameras even focus when you're not pressing the button, but be advised that this mode quickly drains the batteries.

**5** Practise panning the camera horizontally left to right or right to left, keeping your subject centrally in the image.

**6** Once you've selected a subject, track it while keeping the shutter release half pressed. When they are in the right position for your composition, squeeze the shutter release but keep panning the camera, stopping abruptly can ruin the effect.

**7** Try repeating this task with lower shutter speeds such as 1/125, then 1/60. By using longer exposures the motion blur is magnified, however it does become more challenging to keep the moving subject sharp.

3

# Capture motion blur (cont.)

1. Open the camera's flash menu, if your camera has this option you should look for second curtain flash, if this isn't available then select slow sync flash.

2. Check the camera's ISO speed and set this as low as possible – this will enable you to use longer exposures without creating too much digital noise.

3. Put your camera into shutter priority or Tv mode and set the shutter speed to 1/25. Normally a shutter speed this slow would result in a completely blurred photo but here the flash will provide the majority of the light and ensure clarity.

4. Avoid using a tripod or putting the camera down as the small movements of your hands will add to the overall effect. However don't go so far as to intentionally move the camera.

## Motion blur with flash

When the available light is failing or you are shooting indoors it's still possible to use motion blur to great effect. In this task we will look at using a combination of the camera's flash to freeze the movement and a longer exposure to add our blur. On most compact cameras the flash will fire at the beginning of the exposure, which can produce a sharp image with the subject's movement trailing forward. This isn't what we are after as it can make your subject look as though they are moving backwards. This is where second curtain flash becomes useful. This mode switches the flash to the end of the exposure enabling you to freeze the final position of your subject. This mode is ideal for capturing dancers or musicians.

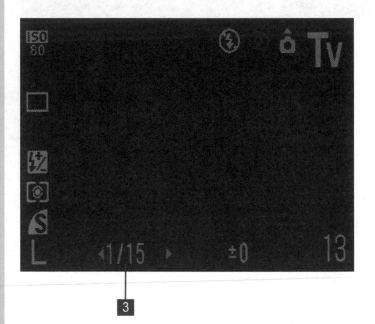

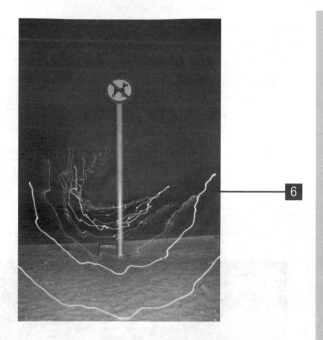

6

5 Once you've selected your subject keep the shutter release half pressed ready to preempt any interesting movement. When your subject is in the right position for your composition, squeeze the shutter release but remember to keep the camera very steady, as any movement will be recording in your photo.

6 Try repeating this task with lower shutter speeds such as 1/15, then 1/5. By using longer exposures the motion blur is magnified, this will also record more of the ambient light making the overall image brighter.

3

# Create a zoom blur

Aside from the movement of the subject there are other ways to create an interesting effect using motion blur. One of the more striking is zoom blur, occasionally referred to as zoom burst. This effect stretches and blurs in a circle around the centre of the frame. For this to really work you must have a tripod handy or at the very least, have the camera resting on a wall.

In order to be able to create this effect you must have a camera with a manual zoom. Many compact cameras control the zoom with a button press or rocker switch so this task can't be completed with them. But don't worry, later we can look at how this same effect can be replicated in Photoshop.

1 First set your camera up on a tripod, and frame the subject you want to photograph.

2 Push or pull the zoom to its widest extreme.

3 Set the ISO sensitivity to one of the lowest settings, for example ISO 80 or 100 are well suited to this task.

4 Set the camera on Shutter Priority or Tv and then configure the camera to use a shutter speed of approximately 1/5 of a second.

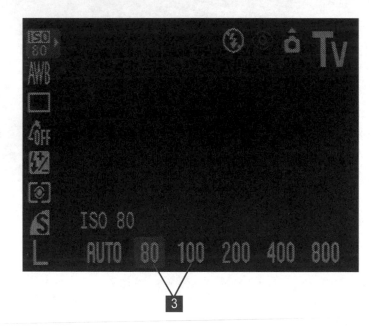

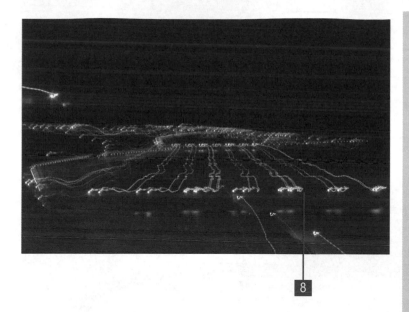

8

## Create a zoom blur (cont.)

5 Lightly depress the shutter release half way to ensure the image is focused.

6 With your hand gripping the zoom lens barrel, squeeze the shutter release so that the exposure begins and simultaneously begin to smoothly zoom in on your subject.

7 After the exposure completes check the image to see if you have been able to capture the desired effect.

8 Try using more or less of the zoom to create different effects – longer exposures can give you more scope to experiment.

3

## Jargon buster

**Electronic viewfinder** – if you consider purchasing a digital camera with a powerful optical zoom you will start to see the term EVF, this stands for electronic viewfinder. An EVF is used to simulate the experience of using an SLR as it can relay the live image coming in through the lens without having to incorporate another bulky lens solely for a viewfinder. Another benefit of an EVF is the inclusion of the current shot settings.

## Shoot at night

Shooting at night may initially seem a romantic choice of setting. However, the degree of patience, calculation and equipment such as tripods required, make it less appealing as a spectator sport. Indeed, photography can be a very self-indulgent hobby and no other branch of it more so than night photography. You can't always rely on the camera's exposure meter, as the longer exposures will begin to throw it out. Ultimately this task is about practice, learning what exposure settings will work best for you. However, don't rule it out immediately, capturing your first cityscape or star trail will more than make up for the energy you expend.

1 For this task you will need a tripod – try and pick something light but sturdy enough to keep your camera safe, and still.

2 Another accessory that may come in useful is a remote release. This can be infrared or cabled. By setting off the shutter release away from the camera you eliminate one of the principle causes of camera shake, namely yourself.

3 First, if you're planning to go off the beaten path familiarize yourself with the route well in advance – remember you will have to come back in the dark.

4 On the day check the weather forecast. This will tell you the obvious things like if it's going to rain, but it will also give you a better idea of the cloud cover and how much light you can expect from the moon. (You have of course, checked that there will *be* a moon!)

5 It might seem obvious, but remember to carry a torch with you.

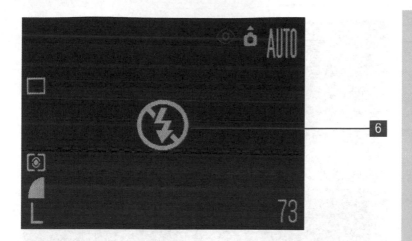

6

8

6 Configure as much of the camera as you can before setting off – it's far easier to do this in your own home than it will be later. If you are planning to photograph a landscape at night disable your flash – on most compact cameras the built-in flash isn't effective beyond around 10 feet.

7 Typically you should use a higher ISO speed on your camera – try setting the camera to 400 or above.

8 Access the camera's Scene mode menu and Night mode or Night Landscape mode. This will enable the camera to take longer exposures and record more of the available light.

9 If your camera features the ability to bracket its exposures this would be an ideal opportunity to use this mode. By bracketing the shots you are more likely to get the exposure you are after.

3

# Shoot at night (cont.)

**10** Half press the shutter release and start the camera auto focusing. It's quite likely the camera will take slightly longer to lock on to the focus point. This delay is due to the fact that most cameras use changes in contrast to focus and darker subjects can present the system with difficulties. If your camera refuses to focus, try switching it to manual focus and doing it yourself.

**11** Once the focus is locked either use the remote release or if you don't have one, press the timer symbol to activate the self-timer mode. Now when you press the shutter release the camera will wait between 2 and 10 seconds before taking a photo. This is another simple way to avoid camera shake.

### See also

Bracketing the exposure involves taking a series of shots with exposures slightly above and below the suggested meter exposure. This is described in Understand when to use Spot, Centre and Matrix Metering.

By using much longer exposures than normal it is possible to achieve some unique effects which provide you with an entirely new perspective on otherwise flat and potential uninteresting subjects. In this section we will look at a couple of techniques that can reinvigorate how you approach your photography. You needn't just look at the simple elements in your photograph but now you can consider how the light will play off the subject, or use the duration of the exposure to infer movement or speed. To illustrate the potential we will go through a step-by-step task looking at photographing moving cars and how you can recreate the attractive images of their trailing lights. We will also examine another way of using your camera by experimenting with torches and an almost pitch black subject.

### Make light trails from cars

**1** As with the previous tasks, a tripod is an absolute necessity. You can try and make use of the environment where you are shooting but you would be well advised to consider a lightweight tripod, it will make your life considerably easier.

**2** The use of a simple remote release is a good idea too – this can be infrared or cable. By firing the shutter release from a remote release you are highly unlikely to suffer any camera shake and your images will be sharper as a result.

**3** On most compact cameras, the standard built-in flash won't carry anything beyond around 10 feet. Thankfully, it's not required for this task. Besides, it is probably not that safe firing a flash at moving cars anyway, not least because they might mistake you for a speed trap. So for everyone's safety, toggle the flash until you get to the lightning rod with a cross through it, which means the flash is disabled.

## Take long exposures (cont.)

▶

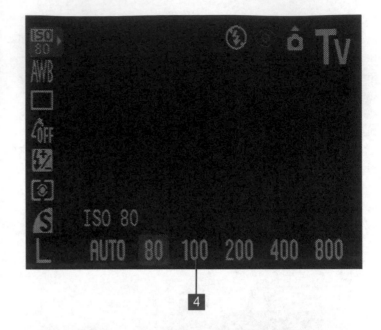

**4**

**4** To achieve the long light trails, we need to reduce the sensitivity of the camera's sensor. This is done by reducing the ISO speed to around 100, meaning the shutter must be open for longer. It has the added benefit of lowering the amount of unwanted digital noise created.

**5** Turn the mode dial or press the menu button to access the camera's Scene mode menu and select Night mode or Night Landscape mode. By using this mode the camera takes longer exposures and records more of the available light.

**6** Half press the shutter release and start the camera auto-focusing. It's quite likely it will take slightly longer to lock on to the focus point due to the lower levels of light. To speed things up, try framing the photo in such a way that a high contrast object is the desired point of focus. If your camera still refuses to focus, try switching it to manual focus and doing it yourself.

Night Snapshot

**5**

## Jargon buster

**Pincushion distortion** – manufacturers try and squeeze the most flexible zoom they can into a camera design but this can mean the image quality offered throughout its working range can suffer. One characteristic problem of bad lens design is known as pincushion distortion. This effect can be seen when looking at the lines of a window – often the straight frame will curve gently inwards.

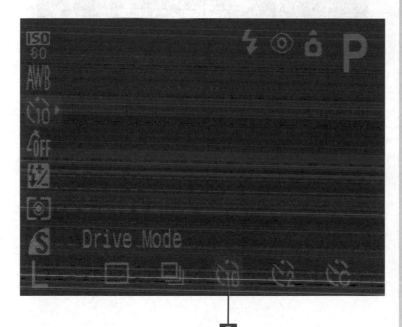

## Take long exposures (cont.)

**7** Once the focus is locked, either use the remote release or if you don't have one, press the timer symbol to activate the self-timer mode. Now when you press the shutter release the camera will wait between 2 and 10 seconds before taking a photo. This is another simple way to avoid camera shake.

**8** If you find the noise levels problematic at 100 ISO try using the camera at a different ISO but with a shorter exposure. Check the effect this has on the photo – your camera may provide better results at a higher ISO. Remember however, that typically a long exposure with a low ISO will be just as noisy as short exposure with a high ISO.

3

# Paint with light

Different lighting can have a profound effect on the way a location, object or person looks – it can change the mood or the ambience completely. Try taking everyday household objects and lighting them with just a simple torch – against a dark environment this light will be the only light recorded and makes for some interesting effects. For this task, try to visualize the childhood experience of playing with sparklers, drawing shapes or writing your name with their brilliant light. Don't worry if your first couple of attempts fall short, just try and enjoy the experience.

1. For this task, a tripod is essential, as the camera will need to be absolutely still. Aim for something light but obviously strong enough to support your camera.

2. Predictably, in order to paint with light we are going to need a torch, if you have different colour filters you can experiment with these too.

3. Access the camera's Scene mode menu and select Night mode. Alternatively set the camera to shutter priority or Tv and use an exposure longer than one second. If it's available, select approximately five seconds.

4. Typically you should use a lower ISO speed – try setting the camera to 100.

5. Point and hold your torch on the area you wish the camera to focus on. This small pool of light won't be included in the photograph but without it the autofocus won't be able to lock on.

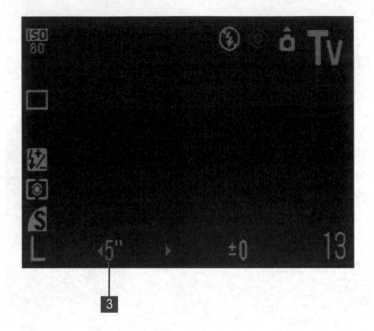

## Paint with light (cont.)

6 Half press the shutter release and allow the camera to lock onto the light from the torch. If your camera still refuses to focus try switching it to manual focus and doing it yourself.

7 Once the focus is locked, press the timer symbol to activate the self-timer mode. Now when you press the shutter release the camera will countdown for 2 or 10 seconds before taking a photo. This gives you an opportunity to get your torch ready.

8 When the exposure begins, move the torch around the area you wish to reveal, holding the torch in any area for longer will make that area brighter in the final photo.

9 Repeat this task at least a couple of times using longer or shorter exposure times – see what you can create.

3

# Hit a moving target with continuous focus

As much fun as it is to select your exposure settings and focus manually, satisfied in the knowledge that every possible compositional choice was made by your own hands, there are times when even the most seasoned photographer will find it hard to keep up with the pace of the action. Indeed you won't find any sports photographer alive who doesn't believe that the advent of auto-focus wasn't heaven sent. This task will look at the use of continuous focus and how to ensure you follow the action. We will also practise panning your shots and provide you with information so you're better equipped to decide the right point to press the shutter. This task will help you to get more shots for your money, and ultimately that may earn you money.

**1** In order for this task to work you must set the camera into a different mode from auto as not all cameras will allow you to alter the camera's focus method while in automatic. If your subject is fast moving you may want to switch the camera into sport mode. Alternatively you can use shutter priority, as this will allow you greater control over the shutter speed.

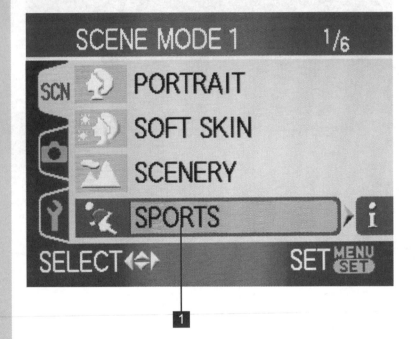

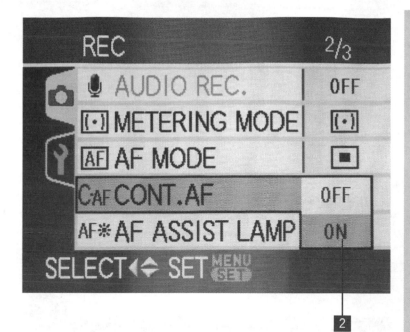

REC 2/3

🎤 AUDIO REC. OFF

⊡ METERING MODE ⊡

AF AF MODE ▣

Caf CONT.AF OFF

AF✱ AF ASSIST LAMP ON

SELECT◀◆ SET MENU SET

2

## Jargon buster

**AF servo** – refers to a camera's ability to continually focus on a moving subject – this feature is sometimes called AI Servo or Continuous. This focus mode is ideally suited to use with sports events or motor sports. To start the process of focusing the shutter release typically needs to be half pressed – on higher-end cameras the camera will even continue to adjust its focus as the image is recorded.

## Hit a moving target with continuous focus (cont.)

2 Once you have switched shooting mode, you must press the menu button and find the auto-focusing options. You are likely to see several options covering aspects such as the available focus points but you are looking specifically for the setting for focusing method. This should allow you to switch between S or Single and C or Continuous – for this task select Continuous.

3 After you exit the menu, you should be aware that the camera is now continually refocusing – this happens even if you aren't pressing the shutter release. By continuously adjusting the focus the camera is always ready to take an instant snap and capture the action, but it does mean a heavy drain on the power so remember to switch back to Single after this task.

3

**Advanced techniques to improve your shots 85**

## Hit a moving target with continuous focus (cont.)

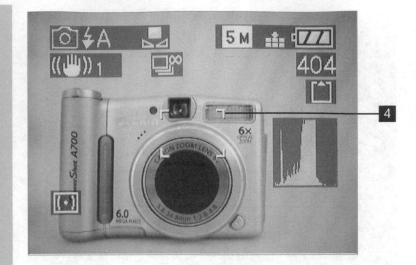

4 On the display of the camera you should have a focus area typically dead centre of the screen. This is where the camera is trying to lock on to, move the camera so that this small square moves over distant and near objects, you should see the image quickly snap into focus between the two distances as you do so.

5 Select a practice subject and try and keep the square over this element, by doing this the camera tracks their movement and adjusts as the subject moves closer or further, ensuring you get a sharp photo. Try this again but hold your finger over the shutter release and try taking a couple of photographs this time.

### For your information

Learning how to follow a moving subject is a vital skill and perfecting this will dramatically improve the quality of your images. However, learning more about your chosen subject can also pay dividends and can be a shortcut to getting better images. For example, taking photos at a dance competition is a great deal of fun but understanding how the dancers move and where the best place to stand is, will always beat even a quick focus.

### Jargon buster

**35mm equivalence** – as digital cameras all have differing sizes of sensors, manufacturers have adopted the standard 35mm measurements to give you an idea on the focal range of the cameras lens, for example a typical 3x optical zoom would be an equivalent of 35–105mm.

Dusting off and rummaging through the old family photo albums can be great fun, joking over past events and poking fun at the previous generation's dubious fashion choices for both haircut and outfits. However if you go another generation back, the black and white photos or sepia tinted portraits have an elegant charm to them. In this task we are going to look at some of the effects your camera is capable of. Believe it or not, despite the cutting edge technology normally shoe-horned into the latest generations of digital compact cameras just about every one on the market allows you to take black and white or sepia, and many more interesting additions.

**1** First we need to switch the camera into P or program AE as this allows us to make changes that otherwise might be unavailable in the camera's fully automatic mode. Rotate the mode dial to P or if your camera doesn't have a mode dial, selecting the P option from its menu.

**2** Next we need to find the camera's colour mode options. The problem at this point is that every camera manufacturer adopts a different way of categorizing this feature. Some place it under scene modes, while others may give these options their own submenu. Canon, for example, have a new section named My Colors.

**3** Once you have found the appropriate menu for effects on your camera, look through the options available to you. Most cameras offer at least black and white, sepia, vivid and neutral, but some extend these features with digital versions of traditional filters such as red, yellow and blue or even stylish new features such as colour accent.

3

## Experiment with digital filters (cont.) ▶

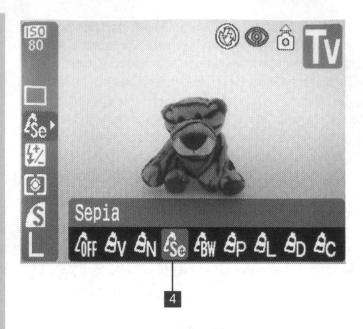

4

**4** For this task we will select sepia – this should immediately change the display colour to give us an idea of what to expect. The display icons surrounding the live image shouldn't change colour but the image itself will have a light brownish appearance.

**5** Now that the camera is configured to use sepia tinting, try taking a couple of shots. Once you have captured some test photos, switch the camera into Playback mode and check out your handiwork.

**6** The next effect we'll look at is the black and white mode. Once again open the camera menu and toggle the current selected effect to black and white. Please note on some cameras this is likely to be under BW or even Mono.

**7** As with the sepia option try taking some sample shots and checking them out in Playback mode.

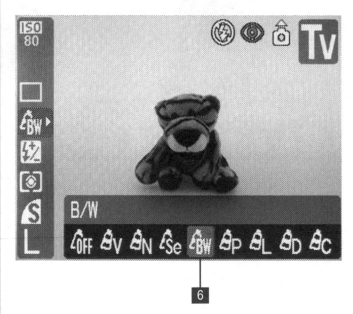

6

The final effect we will look at is the Colour Accent mode. On some cameras this might be under a different name such as colour element. If you are using a Canon camera, note that this effect is separate from the My Colors under the scene modes.

## Jargon buster

**Colour accent** – as computer processors have continued to get smaller and increasingly more powerful, some digital cameras have been able to leverage this additional processing power to add popular effects directly into the camera. Colour Accent converts a colour photo into black and white leaving only one colour element such as a bridal bouquet, which provides a bold contrasting detail.

Colour accent

**8** Once you have selected the Colour Accent mode, try slowly pointing the camera at different subjects as this should give you a good idea how it will typically react to different compositions. Once you are satisfied that you understand which elements the camera is most likely to automatically select to retain in colour, try taking a couple of test shots.

**9** To get a better idea how each of the effects we have looked at will appear, transfer the sample image over to your computer. Which of the effects did you find the most effective?

3

# Use macro photography

It won't have escaped your notice but most digital cameras feature a small icon resembling a flower – this universal symbol refers to Macro mode. This alters the way your camera focuses, allowing it to focus much closer, often as close as 1cm from the front of the lens. Switching to Macro often has the immediate effect of causing the distant objects to blur. With such a close focus, Macro mode is ideally suited for taking pictures of flowers and insects, but there is nothing to stop you from experimenting on a whole host of different objects. In this task we will try photography a flower using the Macro mode.

**1** First we need to select the Macro mode – this is represented by a simple flower icon. If your camera uses a mode dial select the macro by rotating the dial to the flower. Alternatively you may have to push the four-way navigation pad towards the flower symbol.

**2** On most digital cameras this will have the effect of adding the flower symbol to the camera's display to confirm your choice. Some cameras such as Olympus models have two macro modes, standard and super macro. This second mode further reduces the focusing distance making it possible to get right on top of your subject.

**3** Using the macro option to take photos can be successful with or without a tripod, however its good practice to use one. By fixing the camera it allows you to concentrate more on the focus without worrying about your own movement.

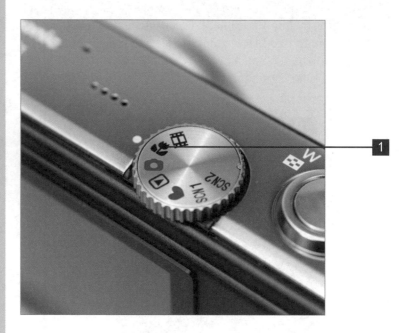

## Jargon buster

**Macro** – the macro setting on your camera allows you to focus the lens very closely. By focusing only a short distance from the lens cameras can capture very fine detail on smaller subjects. Typically macro photography is used for insects and plants, and indeed, the icon for macro is a simplistic flower.

## Jargon buster

**Focal length** – the distance in mm from the centre of the lens to the focal point when the subject is at infinity and in sharp focus. In a digital camera the focus point is the sensor. Focal length is normally represented as mm on the front of the lens. However for these figures to be useful you need to know the 35mm equivalent. Everything lower than 35mm is considered wide angle, over 80mm is normally referred to as telephoto.

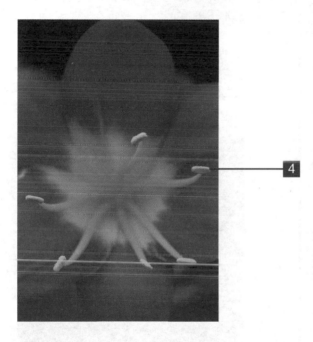

4

## Timesaver tip

For the best results, photograph your flowers first thing in the morning when they're covered in dew, however for late risers a spray bottle of water or glycerine can create the same effect.

4 Select your subject and set up as close as possible. Decide on the element of the flower you wish to capture – with macro photography the depth of field is extremely shallow. Normally the stamens or the pistil are a good choice.

5 Once you have selected the area you wish to highlight, look beyond the subject and check the background is sufficiently blurred so as not to create distraction. It's all too easy to get wrapped up in the subject and overlook things which will later ruin the image.

6 Aside from the clarity of the background consider the colours, if they aren't going to complement the composition you should consider moving to a better vantage point.

3

# Use macro photography (cont.)

7 If you can, disable the camera's auto focus. Auto focusing cameras will work happily with macro photography, however manually changing the focus gives you much more direct control to select exactly what you want.

8 Adjust the focus until you are happy with the composition and then gently squeeze the shutter release. You can choose to use a remote release as this may help to keep the camera steady.

9 Once the camera has recorded the image use the playback function to check the photo's histogram. When photographing the brilliant colours of flowers the metering system may try and compensate by darkening the exposure.

10 If the histogram is shifted to the left, repeat the process but select the exposure compensation and try adding 0.3 to the exposure.

## Jargon buster

**Focal length multiplier** – the advent of digital SLR cameras has meant that many photographers have been able reuse their old lens systems on their new camera. Unfortunately, many digital SLRs use a smaller sensor size than conventional 35mm film meaning that the focal length offered by the lens produces a different field of view, with a narrower perspective. This effect is known as a Focal Length Multiplier. Typically, most entry-level digital SLRs have a 1.5x or 1.6x multiplier – this means that the bundled lenses which offer such alien focal lengths as 18-55mm actually produce similar results to a more conventional 29-88mm.

Focal length multiplier

### Did you know?

#### Exposure compensation

Digital cameras do much of the work of determining the correct exposure for you, allowing you to concentrate on taking your photos rather than configuring the camera. However, on occasions, your camera will struggle to produce the desired results and exposure compensation allows you to override the camera's choice and force it to lighten or darken the exposure. ✱

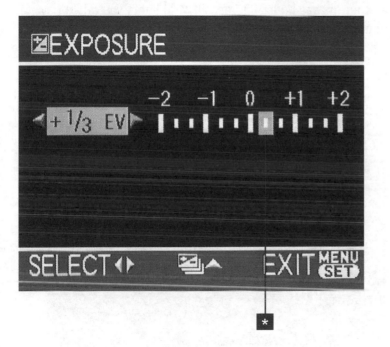

# Understand white balance

In this section we will cover an aspect of photography known as white balance, which refers to the colour or temperature of light. Without wading knee-deep into a science lesson, what you need to understand is that depending on the source of light, the colours in your photo will be different. By default when you put your digital compact into auto mode the entire configuration is put into the hands of the camera, this includes guessing whether it's indoors under a strip light or basking in the sunlight. As you can imagine, despite the advancements in technology this is very difficult for your camera to deduce faultlessly. For example, if you take photos indoors, your prints will typically come back slightly orange, whereas if you shoot all your images under fluorescent strip lights you might have noticed a slight blue tint to your photos. This task will familiarize you with the typical white balance presets and what they are used for.

1 In order to access the white balance option we first need to switch the camera out of automatic. For the purpose of this task, we should select program auto exposure which appears on the camera as P.

2 Next we need to examine the available white balances – on most compact cameras this means we need to press the menu button and select white balance. On some higher end cameras the white balance option maybe directly accessible by simply pressing a button marked WB.

3 Once you have the white balance menu open you will be presented with a variety of preset values, typically represented by simple icons. The camera should currently have auto selected.

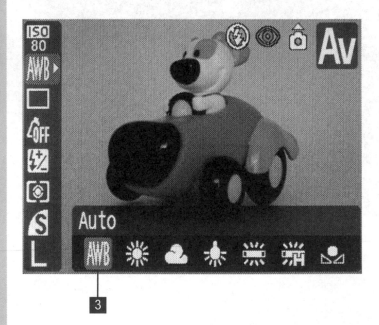

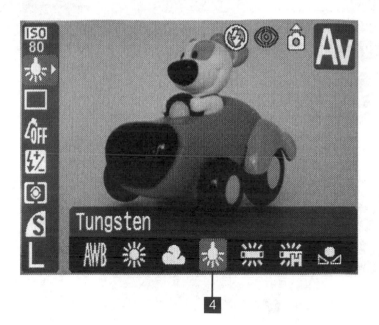

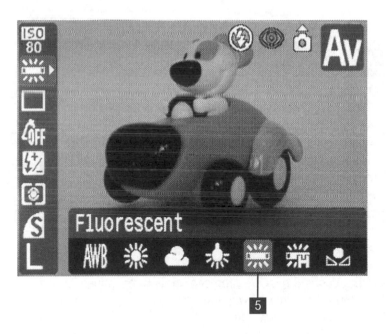

4 Move the camera to the symbol of a small light bulb – notice how the display immediately changes to a slightly bluer tint. This mode is called Tungsten or in some cases Incandescent – it is well suited for most household lighting.

5 Next move the selection to the icon that looks a bit like a glowing magic wand. As you switch to this mode you should notice the display turn slightly orange. This selection is called Fluorescent and is designed for photos taken under strip lighting. Some digital cameras have more than one variant of Fluorescent catering for differing tubes. You just have to experiment to determine the best results.

3

▶

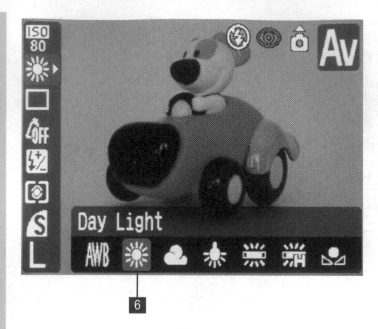

**6** Our next stop is the symbol of the Sun. Rather predictably this mode is configured for and known as Daylight. You will also notice a image of a cloud. If you change to this white balance you may not see much immediate difference from the Sun option. However on a cloudy day, less light comes directly from the sun which gives the photo a slightly blue tint – by using the cloudy option, the camera counteracts this.

**7** Another standard option on most digital cameras is the flash white balance. The burst of light from a flash usually has more blue in it than standard daylight. By using the flash white balance the camera can correct the colours, making the final image more natural.

**8** Depending on the complexity of your camera you may have additional options such as Shade, which works in a similar way to Cloudy only with a stronger correction. You may also have 'Custom white balance', this option allows the photographer to sample the available light and create his or her own white balance.

### For your information

RGB stands for red, green and blue, the three primary colours that make up all light. The retina in the human eye is made up of cells, which are sensitive to the wavelengths of these colours. RGB is often referred to as an additive model which means by combining all three lights in these colours you would end up with a white light, however as we all know if you add all three paints together you would get a dark mess, which is why RGB is used to describe light, for example from a computer display, and to describe printing or any paint based process we would refer to CMYK. On a computer red, green and blue are represented as three values with each number typically ranging from 0 to 255. By using this system the computer is able to reproduce up to some 16.7 million colours, and as the human eye can only discern around 10 million it looks pretty good.

Now we know where the white balance presets are and what they do, it's time to put this into practice. In this task we will try selecting white balances manually and look at the effect of choosing the right and the wrong modes. We will also try using the camera's auto white balance and work out where it fails to provide suitable colours.

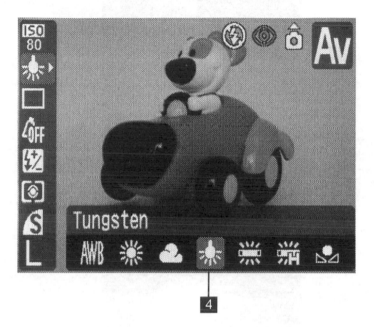

## Use preset white balances

1 For this task we need to take a couple of photos indoors and then a couple outdoors – first we will head outside. If you can bring along someone to photograph this will be really useful to illustrate the changing effect on skin tones.

2 As with the previous task we will set the camera into Program mode P so that we can manually select the white balance.

3 Now that we are in P mode, depending on the layout of your camera either press the WB button or open the camera's menu and locate the white balance options.

4 We will try taking our first sample photo with the wrong settings to illustrate the advantages of selecting the white balance manually, so select the small light bulb symbol to indicate Tungsten or Incandescent.

3

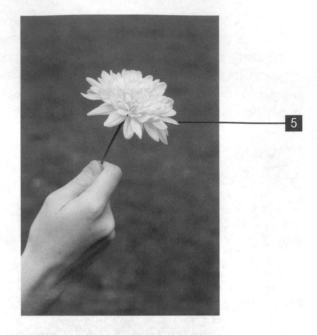

5  Your surroundings as viewed through the camera display should appear cold and bluish, and your model is likely to appear hypothermic. Take a test photo anyway as this will be useful as reference against the next sample photograph.

6  We need to change the camera's white balance to the correct preset for outdoors, so open the camera menu again and select either the sun or cloud symbol depending on the weather conditions.

7  Immediately you should see the camera's display revert to a much more natural representation of the environment around you. By correctly specifying the lighting conditions your images record the right colours and skin tones appear more accurate.

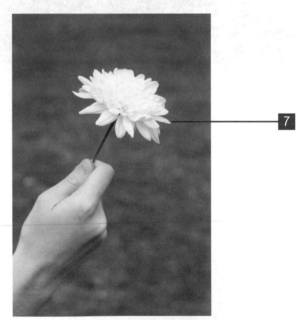

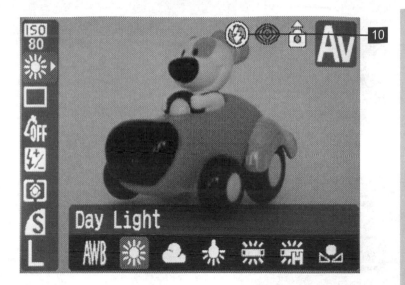

**Timesaver tip**

Your camera's auto white balance can get you through most situations but if you manually select Tungsten when shooting under a bulb you will see the biggest improvement.

8 Take a quick test image and switch the camera into Playback, then use the four-way navigation pad to compare this photo with the previous one. Despite the exposure settings remaining identical, by just using the correct white balance the images should be worlds apart.

9 Now we are going to reverse this experiment and move indoors – again if there is someone around to be photographed that will be very useful.

10 We left the camera set for either Sun or Cloudy so we will try taking the incorrectly set white balance shot first. These images need to be lit by your household lighting and not your camera's flash, so we need disable the built-in flash.

11 Press the lightning rod symbol and select the option to disable the flash.

3

## Use preset white balances (cont.)

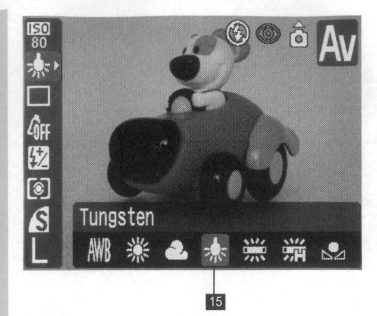

**12** One of the first things you will notice is the addition to the camera's display, of a shaking hand symbol. Your camera isn't sensing movement, it is just warning you that there is very little available light and as a result your photos may come out blurred.

**13** To lower the likelihood of blurred photos try increasing the camera's ISO to 400 or higher to speed up the shutter. Remember also, to squeeze the shutter release gently.

**14** Next take a test shot. This photo should have a strong orange tint to it and your model is likely to look like an oversized tangerine.

**15** Obviously we need to correct this, so dip back into the white balance presets and once again select the light bulb symbol, as a result of this change the display will revert to much more natural colours. Now when you take your photo the room and your model will look as they should.

By now you should be sensing a theme – the histogram is your friend, in fact it's more than a friend, it's pretty much vital. The reason behind this is that your camera or more specifically its display, has a nasty habit of lying to you, it's nothing personal but big bright displays sell cameras, accuracy isn't much of a selling point, yet. Camera displays are generally not accurate representations of the outcome of the photo. This is where the histogram becomes such a key tool. If you learn to make use of the histogram and disregard the appearance of the image for all but the framing you will find the amount of time you spend having to brighten and generally tweak your images will be cut by half. This task will cover the use of both playback and live histograms.

## Use the histogram

### Live Histogram

**1** We will first look at live histograms. Assuming it has one, activate your camera's live histogram by repeatedly pressing the display button until the moving mountain range pops onto the screen. On the current crop of digital compacts, the histogram will typically be a combined RGB one. This means all the colour information is shown in one wave. Some high-end cameras however, go a stage further and show each colour separately.

**2** You will notice as you move the camera, the mountain range undulates, swaying from left to right as the view gets darker and lighter respectively.

**3** Typically the histogram is split into five segments representing from left to right, very dark (shadow detail), dark, mid (18% grey), light, and finally highlights.

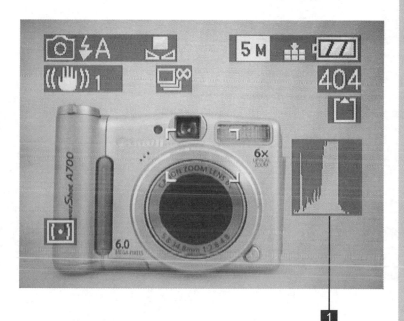

# Use the histogram (cont.) ▶

105-0231
AUTO
1/1250  F4.0
±0  AWB

1.49MB  2816x2112
44/44  28/08/'06  13:38

5

4  Before taking your photo check the peaks. If the histogram shows the curve peaking in the segment to the far left it's likely to be underexposed, conversely if there's a peak in the far right it's probably rather overexposed. To be fair, with these extremes the image would probably have tipped you off to this already.

5  Try framing up a couple of standard shots, perhaps a portrait or landscape, keep your eye on the histogram – the top of the main peak will settle between the third and fourth segment. Take a few test shots and play them back on the camera's display, again they will appear well exposed.

6  Transfer these photos to your computer and ask yourself, are you still happy with the results or could they do with being just a little brighter? It's a fair guess you would be happier with them a bit brighter.

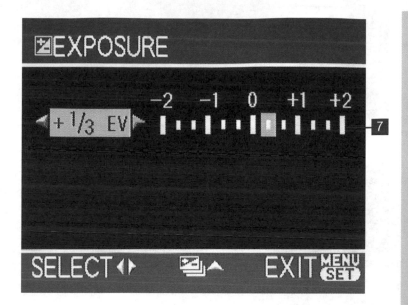

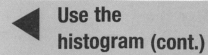

**7** Repeat the same shots, but this time as well as using the live histogram use the camera's exposure compensation feature. Keeping your eye on the histogram's movement adjust the amount of additional exposure until the main peak of the histogram hovers somewhere between the fourth and fifth segment. Remember that the slope shouldn't bunch up at the right edge as this means you are losing the highlights.

**8** These images may initially appear overexposed on the camera's built-in display. Nevertheless, persevere and compare them to the previous batch on your computer – which do you prefer? In most instances, digital cameras intentionally underexpose their photo by around -0.3 EV. This reduces the chance of overexposure but by tweaking this value your colours can become punchier.

3

# Use the histogram (cont.)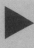

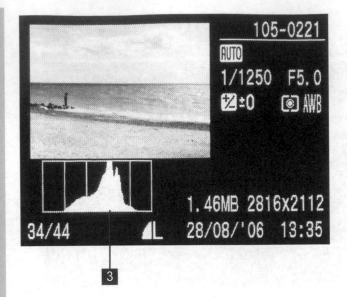

## Playback Histogram

**1** Without a live histogram you can still make good use of the information provided. However, you will find the process requires a little more patience and experimentation.

**2** Compose some typical shots to familiarize yourself with the camera's metering, for example, a group, portrait or landscape and then take a couple of shots.

**3** Once you have your test images, switch the camera into playback mode and press the display button until the histogram information is revealed. If the histogram shows the curve peaking in the segment to the far left it's likely to be underexposed, conversely if there's a peak in the far right it's probably rather overexposed.

## Use the histogram (cont.)

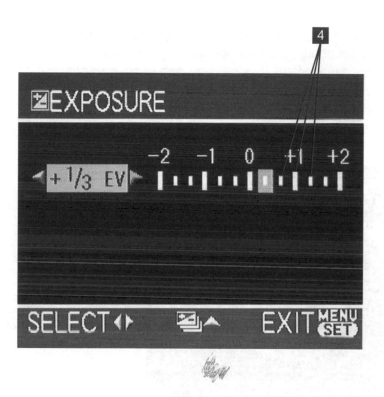

**4** Depending on the location of the main peak, try altering the exposure compensation one step at a time to move the peak into the fourth segment. There is no such thing as a perfect histogram so this obviously won't work for every shot but getting used to the way you camera reacts will stand you in good stead when it comes to tweaking it for the best results.

3

# Shoot in RAW

On every digital camera it's possible to vary the size of megapixel you use to record your photos. This allows you to trade off the quality against the space required to store the photo, choosing lower options for everyday snaps and higher settings for more important events in your life. Sometimes however, the image needs to be the best your camera can record. To get that best, look for the RAW mode. If this is available it avoids compressing or even processing your image in any way at all, leaving you and your computer to take your time with the image, and ensure you get exactly what you want from the photo. Not every camera offers RAW mode as the space requirements for a memory card can dramatically cut down the space available. For example, an eight megapixel camera might offer approximately 400 photos on its top JPEG setting and only 100 on RAW.

1. To decide if your image would benefit from using RAW look at your subject and if it has very dark elements alongside very bright ones then switching the camera into RAW is well advised. You can select RAW for any photos, however, remember the trade-off between space and quality.

2. To put the camera into RAW mode, first switch it to P, S or M depending on your preference. The reason for this is that normally the ability to use RAW is disabled in full automatic.

3. Next access the camera's settings by pressing the menu button.

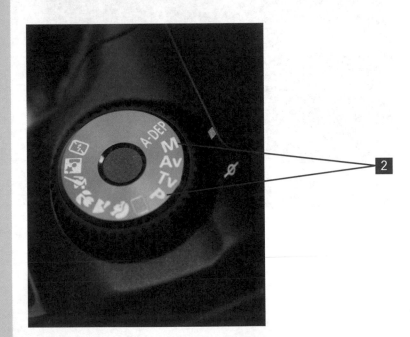

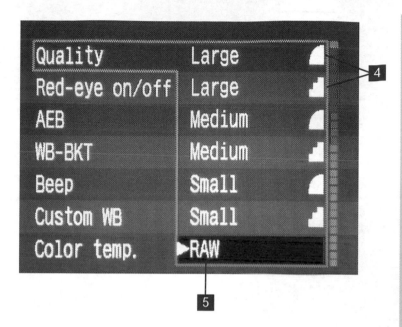

4  Look through the camera's menu until you find the image quality setting, on some cameras this will have a stepped or smooth curve next to it, or the words Norm or Fine to indicate the current quality of the compression.

5  Select the image quality setting and move through the available options until you find the setting for RAW, press OK to confirm your selection.

6  The camera is now ready to take your photo. Once you have captured your images you can still review the image on the camera's built-in display. However, you currently won't be able to print it out or view it on other people's computers. To make this possible, you first need to process your RAW files into a more universal format such as JPEG or TIFF.

### Jargon buster

**Megapixel** – digital cameras record the light coming into the lens on a sensor or CCD (charge-coupled device), these sensors are made up of thousands of individual receptors known as photosites or pixels. A megapixel is one million pixels – modern cameras are typically measured in six to eight megapixels. While it is true the more megapixels the bigger the image is it doesn't directly relate to quality.

# Shoot in RAW (cont.)

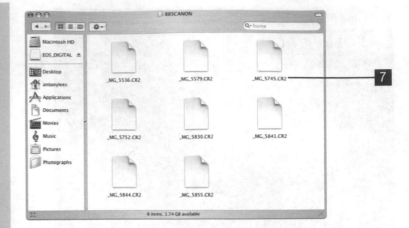

**7**  Next use your flash card reader or USB cable to connect up your camera as you would normally do and open the RAW converter package. At this stage the files will have unfamiliar file extensions, where a JPEG would end '.jpg' or a TIFF '.tif', the RAW files are different depending on the manufacturer of the camera, for example Canon use 'CR2' and Nikon 'NEF'.

**8**  Every package is different, however, you simply need to select your RAW images and use the available tools to adjust the image settings until you are happy with the results. Most RAW converters allow you to make alterations to the photo's brightness and contrast, as well as the white balance. By being able to adjust the white balance in the RAW converter after the image has been taken, it becomes much easier to correct for any unusual colour casts brought about by lighting.

### For your information

#### Selecting the best RAW Converter

If your camera offers a RAW mode, you'll find software supplied to allow you to manipulate it. By rights you would imagine this represents the best program to do this but this isn't always the case. The range of RAW converters out there is very diverse and each package claims to give better results than the others, using better, more advanced, systems to handle your raw files' unprocessed original data. Using different packages does indeed produce a variety of results and some packages seem to have the edge, retaining more of the detail in very bright and very dark areas. With the latest RAW converters, apart from just simply processing the raw data, the more advanced packages also take account of the lens being used and automatically correct for any inherent issues such as the edges of the image being barrelled. Ultimately, don't stick with just the original software, try experimenting with some other packages – after all, they all provide trial versions.

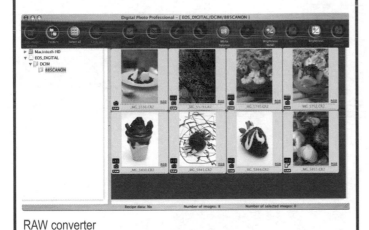

RAW converter

9 Once you have the desired appearance you then need to choose the option for outputting the files. This is normally to JPEG but if you intend to submit the images to a publication or image library you may choose to select TIFF.

10 These outputted files can then be treated in the same way as your standard photos and printed or edited. The RAW files, however, will remain untouched and can be used repeatedly to produce more copies with no loss in quality.

3

# Touching up images

**4**

## Introduction

However you feel about photo manipulation it's become an accepted part of digital photography. With headline-catching scandals such as Kate Winslet's instant digital diet, even the most uninformed reader speculates how much editing has gone into making the glossy cover girls shine. In this chapter we will help you dip your toe into digital editing, with techniques you can use to polish your photos or improve your images to achieve attractive prints. We'll look at potential problem areas and tools you can use to address the issues, while holding on to every last pixel.

## What you'll do

Pick the right tool for the job

Remove red eye

Adjust exposure

Convert colour photos to black and white

Correct colour cast

Sharpen your shots

Control digital noise

Level uneven horizons

Add soft focus

Create a perfect panorama

Selectively dodge and burn an image

Add and remove elements (even people)

Crop your photos ready for print

Add frames to images

## Pick the right tool for the job

### Photoshop CS2 vs. Elements vs. The Gimp

Photo editing packages have been available for computers for some years now, but the undisputed champion has always been and still is Adobe Photoshop. After years of refinement, Photoshop is now an industry standard tool used worldwide, with literally thousands of other programs designed to plug in to the package, making it possible to do pretty much anything to do with imaging. In this book we will concentrate many of our tasks on this package as it will teach you skills that could be used in a workplace. It is, however, a professional tool and not within everyone's budget. To ensure everyone can benefit from their software Adobe created a separate cut-down package called Photoshop Elements which uses the same icons and operates in much the same way as its more powerful sibling. It is however, around a tenth of the cost, making it a much more practical purchase for all but the most avid photographer.

As always there are alternatives: recently Apple have made a bid to reclaim some of the market share with their Aperture software and there are numerous other third-party software houses claiming to be working on powerful editing suites. However, if you are looking for a good photo-editing package and don't have two ha'pennies to rub together, you could try the curiously named 'Gimp' – abbreviated from the Graphic and Image Manipulation Program, which offers many of the benefits of Photoshop but it is completely free, that's right, absolutely free. It might take a little getting used to as its multiple windows don't make it the most intuitive package ever designed, but at the end of the day if you don't like it, what have you lost, just the time it took to download it.

It's a fact of flash photography that when you photograph people at night you run the risk of getting photos back with some of your subjects looking like extras from the cast of *The Omen*. Manufacturers have tried clever techniques that strobe the flash before actually taking the photo but this only works if your subject's eyes react as predicted and contract, which tends not to happen when the people you're photographing are either excited children or ever-so-slightly tipsy adults. More recently, digital cameras have tried a different way of eliminating red eye, by using clever software that looks for human features then when it recognizes the characteristic colours of the eye's retina effectively airbrushes out the offending element. However, even this doesn't catch everything. In this task we will look at the tools provided by Adobe Photoshop to ensure our images only capture the red eyes of sleepless nights and not flashes.

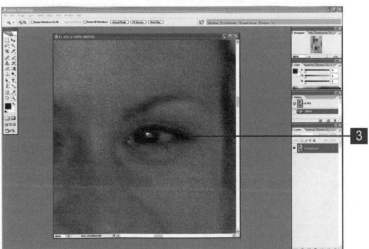

## Remove red eye

1 Start by opening the photo by selecting the File menu and clicking on the Open option. From here, navigate to the folder where your photograph is stored and finally select the file and press the Open button. Photoshop will now open your file, fitting the window to your screen.

2 Choose the Zoom tool, which can be identified by its icon, which resembles a magnifying glass.

3 Move the mouse cursor to the region of the photograph that requires correction and use the left mouse button to zoom in and enlarge the subject area. Repeat the left-click action until the subject's eyes are clearly visible.

4

# Remove red eye (cont.)

| | |
|---|---|
| Spot Healing Brush Tool | J |
| Healing Brush Tool | J |
| Patch Tool | J |
| 5 — Red Eye Tool | J |

**4** If you zoom in too far then hold down the Alt key on your keyboard and press the left mouse button again, so that you zoom out a step.

**5** The red eye correction tool isn't immediately visible, but can be revealed by pressing and holding down the left mouse button over the first icon in the fourth row of the toolbar. By default this shows the spot-healing tool, but once the left mouse button is depressed, a menu will open and whilst still holding it, you will find that it is now possible to move the mouse downwards and select the Red Eye tool, which has an icon of an eye and a cross-hair cursor.

**6** The mouse cursor will become a cross-hair and the toolbar will change to reveal the Pupil Size and Darken Amount options, both of which will be set to their default values of 50%. These settings will be fine with the majority of photographs, but close-up shots such as portraits may require some adjustment.

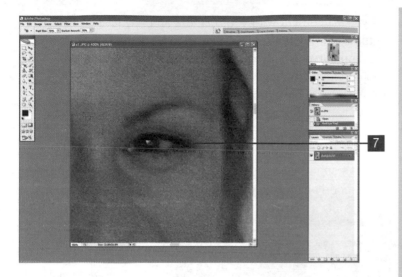

**7** Move the cross-hair over the eye and with the left mouse button, carefully drag a box to encompass the entire iris. When you are happy that the selected region captures all of the red-eye effect release the left mouse button and Photoshop will target the area and darken it, giving a more natural effect.

**8** If the correction fails to eliminate the red eye, or the selected area was incorrect, reverse the process by using the History tab to select the action prior to the red-eye correction and use the red eye reduction tool again. Try varying the size of the selected region, darkness and iris size to produce a natural-looking effect.

**9** Repeat the process with each eye which requires correction in the photograph. Remember to restore the settings for darkness and iris size between subjects in the image.

**4**

# Adjust exposure

As you experiment with your camera and rely less on the automatic exposure modes, there will be occasions when the learning curve will prove more challenging than anticipated and you end up with photos that fall short of your expectations. Don't let it get on top of you though, whether they're too dark or too light, both can be tweaked to bring them closer to your original intention. Ultimately your aim should be to get it right at the time of capture but in this task we'll look at using Adobe's comprehensive Photoshop package to try and improve some poorly-exposed images.

1 Start by opening the photo by selecting the File menu and clicking on the Open option. From here, navigate to the folder where your photograph is stored and finally select the file and press the Open button. Photoshop will now open your file, fitting the window to your screen.

2 Photoshop has many tools which can adjust exposure, including Brightness/Contrast and a dedicated Exposure setting, favoured by those who come from a photography background. However a more flexible option exists in the Shadow/Highlight menu, which can be found by selecting the Image menu option from the top bar and hovering the mouse over the Adjustments option, which will in turn pop open a submenu, here you're looking for Shadow/Highlight.

3 With the Shadow/Highlight window open, select the Show More Options checkbox, which will reveal two additional sets of sliders.

**4** To brighten darker elements of the photograph, use the top slider, labelled Amount in the Shadows section, moving it to the right. You will notice how this only affects the darkest regions of the image, to adjust a broader band of the dark details increase the second slider, labelled Tonal Width.

**5** Conversely, the highlights – which are the brightest aspects of the image – can be adjusted using the Amount and Tonal Width sliders of the second section, labelled Highlights.

**6** Try to use these options sparingly as over-use will drain out all the contrast and flatten the dynamic range of your image.

**7** If the corrected regions of your photograph lack colour or are too deeply saturated this can be adjusted with the first slider in the Adjustments group labelled Color Correction. By moving the slider to the right, relative saturation of the adjusted regions will increase, moving the slider to the left will decrease colour saturation.

4

# Adjust exposure (cont.)

**8** After adjusting the shadows and highlights within your photograph, you may find that the mid-tones, which are the tonal regions between them, also require slight adjustment to finish the image. The second slider of the Adjustments group can do this for you.

**9** Try experimenting with these options to produce a properly exposed and balanced composition.

**8**

In previous chapters we have already looked at ways of using digital filter effects to create black and white photos straight out of our camera. However, sometimes you might look at a photo on your computer and wonder what it would have looked like if you had taken it in black and white at the time, instead of colour. This task will help you explore the numerous ways you can convert existing photos into monochrome, as well as offering some painless advanced techniques you can put to use to add contrast or selectively alter the image's appearance. For this task you will need an image with which to experiment. As a suggestion, landscape photos often benefit most from the switch to black and white.

◀ # Convert colour photos to black and white

1 In this task we will look at three different approaches to converting your sample image to black and white. At the end of each method you can either close the image and reopen it or simply click on the first step in the History panel as this will completely restore the image to its original state.

2 First we will look at the most basic approach. To use this method, first click on the Image option on the menu bar.

3 Next select Mode from the drop-down menu – this will offer numerous options including Grayscale. You need to select this, which will then open a small dialogue box which asks if you want to discard the colour information.

4

# Convert colour photos to black and white (cont.)

4 To proceed press OK and you will be returned to your image, now converted to black and white. However it's important to note that switching the image to Grayscale means you can't add any colour back into it – so if you were going to add accent colours on a bouquet for example, all of your paints will come out a shade of grey.

5 This brings us to our better alternative: this time we open the Image menu on the menu bar once again, but this time on the drop-down menu we need to select Adjustments instead of Mode.

6 Under the heading of Adjustments you should find an option labelled Desaturate. Click this and the colour will be washed out of the image, but unlike Grayscale, this method allows you to paint in any additional colours or give the whole image a subtle tint, sepia for example, or cyanotype.

7 The final method offers the greatest degree of control over the image, retaining all of the individual colour channels but showing them in monochrome. To achieve this you first need to

10

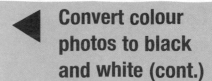
click on Image and as with the previous method open Adjustments again.

8  With the Adjustment menu open rather than selecting Desaturate, click on the Channel Mixer option. This will open a new menu that provides you with the ability to tweak each individual colour. It allows you, for example, to adjust the amount of blue or green, or, via the Constant bar, to alter the image's brightness.

9  This might not be immediately obvious as a method of creating black and white images but at the bottom of the Channel Mixer window is an empty checkbox for monochrome, on which you need to click.

10  Once you have done this, your photo will become black and white but you can still adjust everything as if the colours were still there. For example, in a landscape image, reducing the blue value will usually make the sky much more dramatic.

11  As with the Desaturate option you can still use all the available colours to add to the image or give the overall photo a coloured tint such as sepia.

**Touching up images  121**

# Correct colour cast

Over the previous chapters we have discussed ways to ensure you photos come back with the right colours and looking as they were intended. However, mistakes do happen and sometimes things might appear correct on the camera's display only for the photos to come out with your sitters looking like graduates from clown academy. As we have already tackled how to correctly configure the camera, we will now concentrate on fixing photos on your personal computer or adjusting colours for printing. To ensure their photos are as accurate as possible professional photographers use a device designed to measure and calibrate the colours produced by computer displays and photo printers. Without the benefit such devices, however, we will need to set the monitor display to a preset value such as 6500K. The K stands for Kelvin which is the scale used to describe what is known as colour temperature. The higher the number, the bluer the image is likely to be, while lower values have a warmer appearance.

1. To start with we need to find a photo with inaccurate colours. You are most likely to find this when taking photos indoors as a digital camera may struggle with incandescent or tungsten bulb lighting.

2. When examining your photos for a colour cast, always trust your first reaction to the photo as your brain will quickly compensate for any shift in colour and you will find yourself thinking even the most jaundiced of photos looks fine.

3. Once you have your test image, open it into Photoshop. As with just about everything else in Photoshop there are several ways to approach correcting colour issues and we will look at three of the most popular ones. You can, of course, use the Auto Level or Auto Colour commands but they often fall short of the ideal results so for this task we'll try some more hands-on methods.

## Correct colour cast (cont.)

4 The first method uses a series of thumbnails, each previewing slight changes to the image – this tool is called Variations.

5 To bring the Variation menu up you must first click on Image on the menu bar, this will open up a drop-down submenu.

6 On this drop-down menu, move the cursor over Adjustments, which will bring up yet another submenu on which you will find the Variations command.

4

# Correct colour cast (cont.)

**7** Variation typically displays six images which have each been adjusted slightly – each of them giving you a preview of a different colour tint so that you can quickly make a decision whether that addition of colour is appropriate. Also on the Variations menu is a separate control that shows both a lighter and darker version of the image should you need to adjust the exposure as well.

**8** You will notice that any changes you make only seem to affect the mid-tone colours – as with many of the tools in Photoshop, shadows, mid-tones and highlights are separated allowing them to be adjusted individually.

**9** To switch between the tonal ranges you want to adjust, move to the top of the menu where you will find controls to toggle between shadow, mid-tone and highlights. The Variation tool is a good starting point but despite the visual representation of your photo it can often be very difficult to determine which, if any, changes are appropriate.

**10** When you have made your adjustments to the test image you can either press first step on the History tab to restore the photo to its original colours or simply close the image without saving and then reopen it.

**11** The next and arguably better solution, is to use the Colour Balance tool. This works in much the same way as the Variations tool, with three sliders that allow you to add or subtract six different colours. Once again there are checkboxes to affect shadows, mid-tones or highlights.

**12** To open the Colour Balance tool, click on the menu bar's Image option. As before, move the cursor down to Adjustments only this time select Color Balance.

4

# Correct colour cast (cont.)

**13** Unlike Variations there are no preview panels. Instead the image itself immediately reacts to any shifts in colour, making it far simpler to determine if your tweaks are appropriate. If you uncheck the Preserve Luminosity button it is also possible to alter the brightness of the image.

**14** Once again, when you have achieved the desired colour balance, reset the image as in the last method.

**15** The last option for adjusting colour cast comes in the shape of the Levels control, easily one of the most powerful aspects of Photoshop's arsenal but also, initially, one of the hardest to use. To access the Levels control, first click on Image, then as before, move to Adjustments before selecting Levels from the submenu.

**16** The Levels menu defaults to showing the RGB combined values with a detailed histogram underneath. Directly beneath that are three arrows in black, grey and white. Also in black, grey and white are the droppers on the right of this small menu. These arrows and droppers are linked with the black, 18% grey and white point.

**17** Levels adjustments can be made on colour channels individually or all together. To select an individual colour channel, press the arrow to the right of the channel menu. This will provide four choices, each primary colour along with the combined RGB. For this task select Red.

**18** You will notice that with just red selected, the histogram changes shape. This is because it now shows a breakdown of just the amount of red in the photo. To reduce that, move the grey mid-point marker to the right, to increase it, slide the arrow to the left. This can be done on any of the colours to correct for unwanted tints.

## Correct colour cast (cont.)

**For your information**

When we look at a white page regardless of where we view it, our brain tries to interpret it as white. However, the source of light hitting the page actually has a big effect of the colour bounced back at us. Without a brain to help them out, cameras are far more sensitive to changes in the source of light. This is why digital cameras have numerous settings known as white balances so that you can inform them where the correct white point is. Choosing the correct white balance has the effect of making your images appear far more natural. Most digital cameras, for example, struggle to correctly identify the standard household tungsten bulb lighting which gives photos taken indoors an artificial orange tint. Simply by selecting the bulb symbol from the white balances, your photos can be improved immediately.

19 By combining the three channels you can also alter the image's brightness or contrast.

20 Lastly the droppers we mentioned before can be used to remove any colour cast instantly and also change the brightness of the photo. It takes some practice, but if you select the grey dropper and click on what you believe to be grey on the photo, Photoshop will use this new mid-point information to redraw the whole photo. This often produces excellent results but you need to be careful what you select as grey – get it wrong and your image is likely to go some very funny colours.

If you believe everything you see in the movies you would be able to zoom almost ad infinitum into your photographs with almost no loss in quality, and when it finally did go grainy you'd just need to press the magic clean-up button to reveal that vital bit of obscured information. Unfortunately back here in the real world many digital cameras do sometimes provide slightly fluffy or soft photos. Perversely this is especially true of very high-end digital cameras and SLRs, which are designed to avoid creating unwanted digital artefacts. One of the most common complaints levelled at digital SLR by people making the transition from film or even cheaper digital compacts is the lack of sharpness offered straight out of the camera. This can easily be corrected but in this task we will look at why you might not want to do that. We will look at the best ways with the camera and in Photoshop to make your images really pop with detail without falling foul of any undesirable over-processing.

### Jargon buster

**Artefact** – this term is most commonly used to describe problems attributed to the JPEG compression used by digital cameras. JPEG compression allows many more images to be stored on a memory card than would otherwise be possible but poor implementation can introduce a stepped appearance to normally smooth lines, or unwanted patches in solid colours.

## Sharpen your shots

**1** When your camera, regardless of brand or price, takes a picture that isn't set in RAW mode, it will record the information provided by the sensor, then apply adjustments to the colour, sharpness and noise in order to try and present you with the most appealing photo. By default, compact cameras typically employ slightly more sharpening than a DSLR.

**2** To adjust the level of sharpness offered by default from your camera you first need to open the camera's Setup menu. Depending on the camera, this can be done in a number of ways: with Nikon compacts it's normally contained within the setup option on the dial; on Canon's, you can find the variables under the Menu option.

4

5

**3** When you find the image settings the camera will normally be set to +1 or slightly sharper. If you find your photos aren't sharp enough and you don't want the hassle of sharpening your images later, you could experiment with trying higher settings. Boosting the contrast of your photos slightly will also make them appear sharper.

**4** However by using the camera to sharpen the photos you won't be getting the best results. This is because the brains of your digital camera, while undoubtedly very clever especially considering their diminutive dimensions, aren't as advanced as the algorithms employed by Photoshop on your home computer. By using Photoshop to sharpen the photos later you can get much more detail from your images.

**5** To sharpen your images in Photoshop first open your photo by clicking File then Open and browsing to your photo's location.

## For your information

### Unsharp Mask

The term Unsharp Mask refers to a tool within modern photo editing packages that is used rather confusingly to actually sharpen the photo. The contradictory name originates from a printing technique that used a slightly blurred positive image combined with the original negative to creating the effect that the final print was sharper.

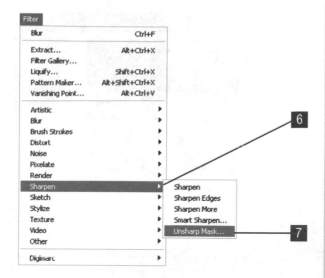

6 Once your photo is open, press the Filter option along the top menu bar – this will open a drop-down menu offering a range of choices, select Sharpen.

7 Even as your cursor lands on it, a second submenu will appear to the right of the first with several additional choices. While it sounds contradictory the one we need is the Unsharp Mask.

8 This will open a small menu with a preview window and three sliders to adjust the amount and style of sharpening you're after. The first line is self-explanatory and indicates the amount of sharpening in terms of percentage you wish to apply. This slider normally defaults to 100%.

4

# Sharpen your shots (cont.)

**9** The next line is entitled Radius and refers to the area over which the program compares the colour or the pixels. The higher the value the more obvious edges become but at the expense of surface detail.

**10** Finally there is the Threshold value, this allows you to specify a minimum size of dot in the image to sharpen or ignore and can be useful if, for example, you don't want to accentuate dust on negatives.

**11** From here you will have to learn the characteristics of your own camera and adjust the Unsharp Mask until you find a balance that provides plenty of detail without creating telltale halos around markedly contrasting subjects.

**12** As recommended starting points, try raising the amount value to 150% and reducing the Radius to 0.3 pixels. The effect should be very subtle but just enough to bring out people's eyes in portraits and hidden details in landscapes.

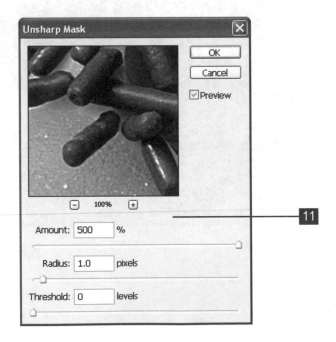

If you look at the majority of your photos you are unlikely to be particularly worried by any obvious examples of digital noise. However, now that we've shown you how to claw back details from even the darkest shadows you're going to start to become more and more familiar with this unwanted pest. Other occasions that prompt the arrival of digital noise are longer exposures or use of particularly high ISO settings for late-night snaps without the use of a flash.

Whatever the reason for noise, the results end up the same, a speckle of random pixels and colours that appear over the top of your original composition. In this task we will look at how you can use Photoshop to remove digital noise without losing too much of the detail of the original image.

1 First of all open your test image, preferably choosing an image taken later in the evening. The failing light always presents digital cameras with more of a challenge and the picture is much more likely to show signs of noise.

2 Photoshop has several different tools for removing noise or in some cases adding it, should the photographer require that, but we are going to use the Reduce Noise filter.

3 As its name suggests you can find the Reduce Noise tool by clicking Filter on the top menu bar, then moving down to Noise. This will pop open the submenu and allow us to select Reduce Noise.

4

# Control digital noise (cont.)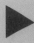

4 Upon opening the Reduce Noise tool you will be presented with a large preview window on the left of the menu, and on the right, four sliders controlling how the tool works.

5 From the top down, the individual sliders control first the strength of the noise reduction, this can be set anywhere from 0 to 10. At 0 there is no noise reduction employed, at 10 the image is subjected to very heavy-handed noise reduction which removes all the unwanted fizz but also smoothes over much of the photo's detail. To get the best results try moving the slider back and forth to see where you are happy to compromise.

6 The next slider works in conjunction with the first, helping to cling on to as much as detail as possible. This control is labelled as Preserve Details and moves from 0 to 100%. Again try experimenting to familiarize yourself with how the two can be used to best effect.

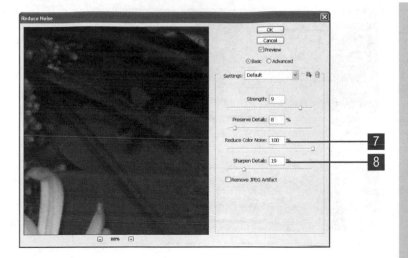

**7** The next slider targets colour noise which is perhaps the most obvious issue created by digital noise. This slider works much like the previous control and can be set anywhere from 0 to 100%. Employing higher settings easily removes any coloured speckles however it does have the side effect of making brighter colours a little flat. Again use it in moderation.

**8** In order to help retain as much detail as possible the Reduce Noise tool has a built-in sharpening tool under the guise of the Sharpen Details slider. Another percentage control, you can opt for as little or as much sharpening as you require. Alternatively deal with the noise first and sharpen the image back up again as described in the previous task.

**9** By default, the Reduce Noise menu is set to basic mode. However, for those of you confident enough to handle even more options you can switch to advanced mode by clicking on the appropriate empty checkbox.

4

# Control digital noise (cont.)

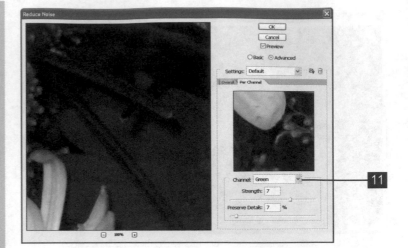

10 In advanced mode, a second tab appears behind the overall setting. This new submenu features another monochrome preview window that allows you to check out which colour channel contains the most noise. Once again there are sliders for Strength and Preserve Detail.

11 By specifying how much noise reduction you want you can tackle a colour channel at a time and target a camera's specific weakness without over processing all the other channels.

12 If you find yourself constantly repeating the same variables to improve photos on your camera you can save the settings for quick recall by clicking the miniature floppy disk symbol. This will then ask you to give these variables a unique name and they will be added to the Settings list for quick access.

## Jargon buster

**Noise** – to photograph in low light or to use faster shutter speeds with film you might choose a higher ISO rated film. Its chemicals react faster to light, allowing additional creative options. The trade-off however, is that this film has a more obvious grain to it. Digital cameras emulate faster ISO speeds by amplifying the signal, which can introduce unwanted coloured pixels into the photo.

One of the most common mistakes when photographing landscapes is to get a slanting horizon. As most of us don't carry a calibrated tripod with us when we go away on holiday, our compact cameras can make it difficult to judge. Don't despair though, with the advent of straightforward photo editing packages we can fix your wonky horizons without a spirit level in sight. For this task we are going to use Adobe's Photoshop package, although most home editing packages have similar options to fix this problem.

## Level uneven horizons

1 After transferring your photos to the computer find the lopsided landscape and open it in Photoshop.

2 Once the image has loaded select View from the Photoshop tool bar.

3 Next from the drop-down menu select the option New Guide.

4 This will open a menu asking if you require a horizontal or vertical ruler. For this task select a horizontal ruler.

5 Also on the same menu it will ask the position at which you would like the ruler. Make a guess at this but don't worry about being too accurate as we will move it later.

6 The ruler will then appear as a blue line across your image. This won't, of course, appear on the prints but it does serve as a perfectly flat guide.

7 Press down and hold the mouse on this new line and move it so that it cuts across your wonky horizon. Then let go of the mouse to set the guide or ruler in place.

# Level uneven horizons (cont.)

**8** Next press the Maximize Window icon so that the image fits neatly in the screen. If the image is still larger than the screen, select the Magnifying Glass and then switch the tool to zoom out by keeping the Alt key pressed down. Whilst doing this, click anywhere on the photo to zoom out, repeat this until the photo fits in the screen.

**9** Next select the Rectangular Marquee tool and move the pointer to the top left of the image. Press and hold the mouse button and drag the pointer to the bottom right corner, this should select the whole photo.

**10** The photo should have what appears to be 'marching ants' going around the outside. To allow you to rotate the image you must select the Move tool. This now adds nine boxes placed evenly around the outside and centre of the selected area.

## Timesaver tip

You can add a new guide by simply pressing, holding and dragging a guide from either the horizontal or vertical rulers which can then be placed directly where required.

# Level uneven horizons (cont.)

**11** To rotate the image move the pointer to just outside one of the corners. This should change the pointer to an arching arrow. Now press and hold the mouse as you rotate the photo so that the landscape matches up with the horizontal ruler. Don't worry if the image looks very rough this is because it only redraws properly when you confirm the position, which is done by either double-clicking or pressing Enter.

4

# Add soft focus

One of the most common light-hearted remarks you will hear is the request from your sitters, both male and female, to edit your photos to conceal their imperfections: a little wrinkle smoothed here; softening the skin there; and, of course, 'Can you take a few inches off my waist?'. While all of these are possible, this task will concentrate on one of the least invasive, the addition of soft focus. When operating outdoors on a bright day your compact camera will typically try and offer as much depth of field as possible, but there are often situations where this isn't actually what you want. For this task, we won't be applying a thick coating of Vaseline to the lens to blur out the rigours of time on our models, instead we will selectively blur out the background. Correctly used soft focus can allow you to narrow the depth of field in a photograph, accentuating the meaning and ultimately improving the image.

**1** With portrait photos it's preferable to have the background slightly softer as this draws your eyes to the person rather than the periphery. First off we need to open the image we wish to edit in Photoshop. As before, we do this by clicking File on the top menu, then Open on the drop-down menu. You can then navigate to your image and select Open.

**2** This will pop the image up on the display and we can begin our selective blurring. As with so much in Photoshop there are numerous ways of achieving this: you could simply select the seventh icon down on the tool bar – called the Blur tool and brush over the sharper areas until you achieve what you were after, but this is a rather haphazard method and usually doesn't look that effective. So instead we will opt for a more involved but consistent approach.

3 First move your cursor over the Layers tab and press the right mouse button on the layer called Background. This will open a submenu, from here select Layer from Background.

4 You should now be presented with a dialogue box asking you to name the new layer. You can do this if you wish but otherwise just press OK.

5 This will return you to the Layer menu, with the new layer 0 or whatever you called it, selected. With the new layer still selected, press the right mouse button again and this time click Duplicate Layer. Once again Photoshop will ask you to name the new layer once you have pressed OK.

6 This should create a perfect copy of the first photo layered over the original. Next you need to ensure the top layer is the one selected for editing. This should be obvious – the selected layer appears in blue, if it isn't, simply left-click it once.

# Add soft focus (cont.)

**7** Select Magnetic Lasso from the tool bar. (This option is initially hidden and requires you click on the Standard Lasso icon, found second down on the left of the tool bar.) You can then toggle between the various types of lasso by pressing and holding the left mouse button on the icon. This will reveal a submenu from which you can choose the Magnetic Lasso.

**8** Once you have the Magnetic Lasso, left-click next to the subject you wish to blur. This will start Photoshop creating a lasso and as you trace the outline of the area it will draw a line that snaps to the outer edge.

**9** You will notice small squares appearing on the line, at these points the line can bend more acutely so if you find the line won't turn enough, press the left mouse button again to drop an additional square.

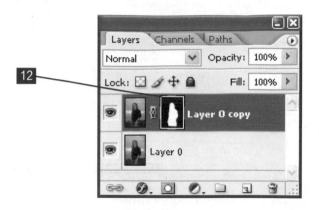

12

10 Likewise if you want to backtrack a little, simply press Backspace. This will remove the last square and allow you to try navigating that nook or cranny again. For dead straight lines such as the edge of the image you can hold down the Alt key as you press the left mouse button once. This will toggle you to Polygon Lasso for one line, making it better suited to follow the edge.

11 It may take a couple of attempts to get the lasso perfect but once you join it in a loop the line will switch to the familiar marching ants.

12 At the bottom of the Layers menu is a rectangle with a circle in it, left-click this once to create what is known as a Layer Mask. If you have done this correctly you will notice a silhouette of the area selected next to the image on the layer menu.

4

# Add soft focus (cont.)

**13** At this stage you have the mask itself selected rather than the image. This can be confirmed by checking the name of the file along the top of the photo window, it will have a bracket after it saying Layer Mask. To continue working on the image left-click on the thumbnail image to the left of the new silhouette. The title of the image should switch to RGB or CMYK.

**14** Next, click on the Filter option on the menu, this will open a submenu where we select Blur. Here we are offered the complete range of blur effects. Depending on the subject, different effects are better suited to getting the look we are after. For example, with a portrait our subject is stationary so we should opt for Gaussian Blur. However if you are photographing motor sports the motion blur might be preferable. We will look at both but let's start with the Gaussian Blur.

**15** Once we have selected Gaussian Blur this will open up a new menu, with a simple slider. Try moving this back and forth until you get the effect you are after. Always try to use slightly less than you initially thought, this ensures you get the effect you want without making the effect too glaringly obvious.

**16** If you were tackling a sports photo the motion blur can be used in a similar way to the Gaussian Blur menu, however apart from just the level of blur, you also need to consider the direction of the movement. To achieve this you are provided with a text box to type in the exact angle if you know it or more likely a simply rotating dial which you can adjust until the effect looks appropriate.

**17** Finally press OK and then save the image by clicking File and choosing Save As. It's good practice to alter the original filename to reflect the addition of blur.

4

## Create a perfect panorama

Digital cameras have inherited a lot from conventional film cameras, not least the standard focal range they offer. Most compact cameras don't offer a very wide perspective, typically only 35mm. As a result, for landscape photography this can only provide a limited expanse of the horizon, never really capturing the majesty of a spectacular view. However to combat this limitation, digital cameras now offer a panoramic mode, which allows you to electronically stitch a sequence of images seamlessly together. This task will look at the best way to capture each photograph and then examine how to use the software package to achieve the best results.

1 Getting a good panoramic photo begins with how you take the images that make it up, the more care you take with the capture the easier the image will come together and the better the results will look.

2 Ideally when taking photos which are to become a panoramic image, you should always use a tripod. This ensures your images are all taken at the same height, and with better tripods and more than a little care you can even use the degree markers on the tripod to reduce the amount of overlap required. You can still create a panoramic image without a tripod, you just need to try and keep the camera as level as possible.

3 If your camera offers a panoramic mode, turn the Mode dial or access the menu to activate this feature. The camera will either overlay a translucent version of the previous frame on the side of the image, allowing you to line up the same landmark easily or simply add markers on the screen to assist composition.

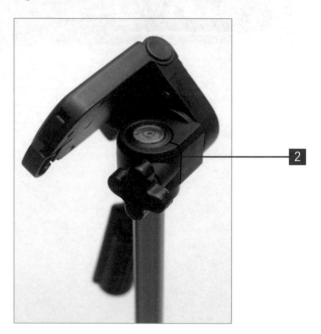

## Jargon buster

**Barrel distortion** – compact digital cameras balance flexibility against picture quality, nowhere is this compromise more evident than in lens construction. When buying a digital camera shoppers often look for the longest zoom they can find. However, this can mean that the lens has trouble ensuring the lines in the image are straight at its widest point. Take, for example, a door frame where the lines gently bow outwards – this effect is known as barrel distortion.

**4** Keeping in mind that you need to be able to identify where your last photo ended, line up your first photo with an eye on the landmarks towards the edge of frame. When you're happy with the image, take the shot.

**5** Now, keeping the camera level, and without moving backwards or forwards turn the camera to frame up the next section of the horizon. Here is where you need to line up the edge of the previous shot with the beginning of the new one, allowing for approximately a fifth of the frame to overlap.

**6** Keep repeating this process until you have the shot you want or have come 360 degrees and joined up with the original photo. It's important to be careful when building up a panoramic shot but don't worry too much if your images show some distortion such as barrelling, this can be corrected with the software later.

# Create a perfect panorama (cont.)

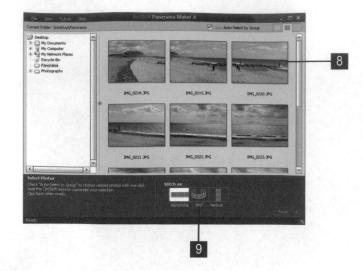

8

9

**7** Back on the computer we now have the task of stitching the individual images together to create one long strip. It is possible to achieve this in Photoshop but there are purpose-built applications much better suited to the task. Most digital cameras come bundled with a free package – we will be looking at Arcsoft's Panorama Maker 4.

**8** Upon opening Panorama Maker, you will be dropped straight into the My Pictures section of your PC, from here you can navigate to the images you wish to stitch together.

**9** Along the bottom of the window you will see there are several options for the format of the panorama, you can either go horizontally, vertically or if your image spanned a full 360 degrees you can create a wrap-around image. Select the appropriate type.

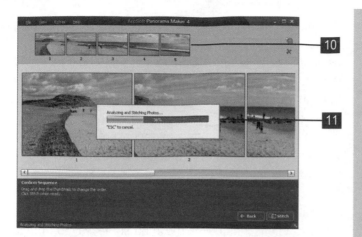

**10** To begin the process of stitching them together, press the next button on the bottom right. This will move you on to the next stage where you can alter the sequence of the images if required. Simply press and hold the left mouse button and drag each image into the correct position.

**11** Next, click on the stitch button in the bottom right. This will then look for similarities in the images and decide how the images should link correctly. When the process has finished you will be provided with the fine-tuning screen that allows you to manually override some of the decisions made by the computer.

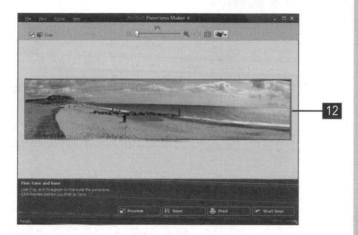

**12** In this menu you can also adjust the crop of the image to include more or less of the final print. If the result falls too far short of what you want or the sequence was incorrect, you can choose to start over again. However once you are satisfied with the results remember to click Save because none of the image is saved up until this point.

## Selectively dodge and burn an image

Photography is great fun but there's no denying that when you're under pressure to get a great photo and your model is beginning to look a little irritable there can be a lot to remember. So it's all too easy to overlook the basics such as the lighting or how much of your model's face is in shadow. However, don't be too hasty at hammering away at the Delete button – if your model has a perfect expression maybe it's worth saving. This task will look at the use of both the Dodge and Burn tools; these controls are derived from some essential darkroom skills, but here you can use them like a master without ever having to fumble about in the dark. By employing these simple techniques you can go some way to bringing out the best of your images. It won't, however, make genuinely poor images wonderful, that's what practice is for.

 Looking back over some of the previous tasks we have already examined ways to adjust the exposure of your whole image to restore otherwise hidden details. For this task we are going to familiarize ourselves with tools designed to allow us to make more subtle changes to any point of the image big or small, these tools are known as the Dodge and Burn tools.

2 We will start with Dodge. This tool is represented on the tool bar by what looks like a black lollipop. When you left-click on it, you will activate the Dodge mode. This changes the top menu to show the brush size, range being targeted, whether it's shadows, mid-tones or highlights, and finally the exposure, which controls how fast any changes are made.

3 As you move the cursor over the image, the icon should switch to a small circle – this indicates the area that will be changed if you press the left mouse button.

4

**4** As an experiment, switch the Range drop-down menu to highlights and increase the exposure to 50%. Once you have done this, choose a lighter element of the picture and hold the left mouse button while moving the cursor in small circles over the bright area. What effect has this had? You should see an even brighter circle quickly appear in the centre of this area but you will also notice that at least initially, the underlying detail was retained.

**5** What you have just done is an exaggerated version of normal practice. Typically if an element of a picture such as a face need slightly brightening up, simply choose a large brush with a low exposure value and gently lighten these features up. As always try to use moderation to keep the effect realistic.

**6** Return to the original image by clicking the first step on the History panel.

4

## Timesaver tip

To quickly alter the size of the brush you are using in pretty much every part of Photoshop you can press [ to reduce the size and ] to increase it. You can also change the hardness or softness of the brush by pressing Shift at the same time.

## Selectively dodge and burn an image (cont.)

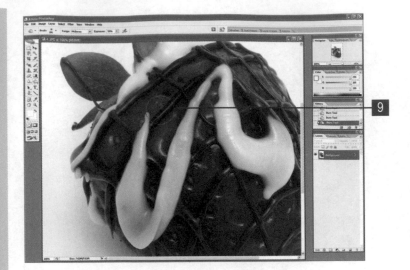

**7** Of course as many times as we might need to brighten up an image, there are occasions when we need to darken washed-out elements. This is where the Burn tool comes in to play. The Burn tool is hidden under the same icon as the Dodge option and requires you press and hold the left mouse button to access the hidden submenu.

**8** The Burn tool looks like a hand pinching, but once selected the cursor switches back to the same familiar circle. As with the Dodge tool the menu bar along the top switches to the same options.

**9** Thanks to the separated ranges it is possible to darken lighter aspects without unduly changing the neighbouring detail. Just make sure you choose the highlights rather than mid-tones or shadows.

**10** When this tool is used sparingly and in conjunction with the Shadows/Highlights tool detailed in the 'Adjusting exposure task', it's possible to correct all but the worst photos. These tools are definitely worth practising with, but nothing beats getting the exposure right.

One of the most attractive aspects of digital photography is the ability to edit your images. This can be for fairly minor alterations such as adjusting the brightness or contrast of your snaps, or it can be on a much more adventurous scale such as the inclusion of people into family photographs who couldn't make it on the day, or the removal of unwanted elements such as a wheelie bin from the background of your wedding photos. Ultimately the only limitation is your imagination. For this task we will look rescuing an otherwise good image by removing small unwanted elements from the scene.

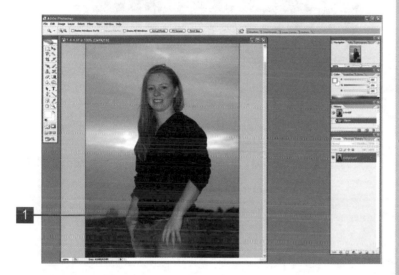

## Add and remove elements (even people)

1 For the purpose of this exercise find a digital image with something wrong with it, whether it's a scratch or blemish, or indeed something that was present at the time of capture you would prefer tidied up or removed such as that unwanted wheelie bin or someone using their fingers to add bunny ears to your portrait.

2 This task will look first of all at the different tools at your disposal and how you can make the best use of them. We will start with the Clone tool, the icon for which resembles an old-fashioned rubber stamp and is located five buttons down from the top. Put simply the Clone tool works by copying from one area of an image to another. This allows you to select a good area such as blue sky and copy over a bird for example.

4

# Add and remove elements (even people) (cont.)

**3** In order to correctly use the Clone tool you must first indicate where the tool will copy or sample from, this is known as anchoring. Holding down the Alt button changes the mouse pointer to a target, next select the area to sample from.

**4** Move your cursor to the area you wish to copy over and press the left mouse button, notice that as you move the cursor, the original area being copied moves in exactly the same way. The Clone tool can be used for repairing damage to old photos or with a steady hand removing objects or people.

**5** As the task's name suggests, it's also possible to add people or elements in that weren't previously there and the Clone tool can be used for this too. Simply open a second photo containing the aspect you want to blend in and anchor the Clone tool on the second photo then switch back to your original photo and brush the new item in.

## Add and remove elements (even people) (cont.)

**6** Then next tool available is the Patch tool. This work in a similar fashion to the Clone tool, copying good parts of the image over bad. First we select the Patch tool by pressing and holding the left mouse button on the fourth icon down on the tool bar, this will look like a plaster. When you hold down the mouse button it will reveal two or three additional options one of which resembles a patch, predictably this is what we are after.

**7** Once you have the Patch tool selected, the cursor will change to an identical little patch. Holding down the left mouse button, draw a line around the problem area of the image, making sure that the ends of the loop meet up.

**8** This will create a loop of marching ants around the problem area. Next move your cursor into this loop and drag it using the left mouse button over to a similar but preferable area of the image.

## Add and remove elements (even people) (cont.)

9 When you let the mouse button go the computer will try and calculate how to incorporate the new area and should eliminate the problem. The Patch tool is perfect for getting rid of rips in old photos but be careful because it samples from all around it and if there are big changes in contrast these can leak into the repaired area.

10 We've all heard tales of super models having their skin cleaned up with Photoshop. Now here's you chance to use one of the tools designed specifically for removing every kind of spot. Return to the Patch icon and once again, press and hold it until the menu appears. Select the plaster with the small circle behind it – it should be labelled Spot Healing Brush tool.

# Add and remove elements (even people) (cont.)

**11** The Spot Healing Brush tool works much more directly than the two previous tools. When the icon is chosen, the cursor changes to a small circle that you move over small blemishes and then press the left mouse button. One click and they're removed and it's on to the next one.

**12** By using a combination of these tools you can either remove small problems, patch up damaged photos or copy trees over unwanted aspects of an otherwise perfect horizon. It's worth practising with all three tools as no single one of them can be used for everything.

4

## Crop your photos ready for print

When you set about taking your photographs you usually wait for the right moment, preferably when everyone is looking towards the camera, or after that frustrating stranger ambles out of the wonderful landscape you're trying to capture. So it's not surprising that after your due diligence you are a little frustrated when the photos come back from the photo lab with the tops of relative's heads lost over the edge of the picture or sightseeing snaps literally loped off in their prime. The reason for these omissions is not because the developers want to squeeze more money out of you to run the prints through again, it's because pictures from digital cameras don't actually fit in a standard 6x4 print. The light-sensitive sensor in your digital camera is smaller than the area normally occupied by the film in a conventional 35mm film camera. This, however, isn't the problem. In the move to digital, the camera manufacturers didn't match the ratio of the old 35mm film to the ratio of the new digital sensors, meaning prints from digital are slightly taller than 6x4 and either need you to print bigger photos or crop the photos yourself. In this task we take the guesswork out of cropping your prints.

1 When you have some photos that you would like to print, open one of them in Photoshop. You can either: click on the File option from the Photoshop menu bar, select Open and navigate to your images or alternatively with Photoshop already open you can drag the images either one at a time or in multiples directly onto the open workspace.

2 If you have chosen to open multiple images the computer may take a little while to complete opening the images – if you can try to keep to less than five photos at a time.

3 Before we begin you need to decide what size you would like the prints to be. The most common selections are 6x4 or 7x5 but remember that if you want to you can crop the same image several different ways if you want to get some enlargements. You just need to save the variations under different names. Using the dimensions in the title is one handy way of quickly identifying which is which.

4 Now we need to select the Cropping tool. This option can be found a third of the way down from the left on the Photoshop toolbar. Once you have selected the tool, when you move the cursor over the photo it will change to the same overlapping Ls.

5 Before you use the tool on the image, look at the new menu bar along the top of Photoshop this will have changed to show a width, height and resolution field. The first two may be empty with the resolution field showing 72 pixels per inch.

6 You can type directly in to all three fields, for Width type 4 inch and in Height type 6 inch. As you press Return you will notice the word 'inch' is abbreviated to 'in'. Under the Resolution field type in 300 – this will ensure your prints retain a high level of quality.

### Timesaver tip

If you don't have the time to go through your images cropping them the way you would prefer, you can always simply print them 7x5, this format still crops a little from the top but the effect is much less noticeable.

# Crop your photos ready for print (cont.)

**7** Try pressing the left mouse button at the top left of your photo and with the button still depressed drag it as far as it will go towards the bottom right. These settings will restrict the way the Crop tool works ensuring the ratio is correctly preserved and you can get what you expect.

**8** If your photo is vertical (i.e. portrait) rather than horizontal (landscape), the Crop tool won't allow you to get very much in, however you can easily switch from portrait to landscape by pressing the opposing arrows on the menu bar between the width and height fields.

**9** After you drag the Crop tool over the area you wish to keep, everything outside this area will become greyed out, however at this stage you can still tweak the area to be cropped. By pressing the left button anywhere in the centre you can move the area around. Also by pressing on the four corners you can adjust the cropped area's size.

## For your information

### CMYK

The term comes from printing – CMYK represents the four colours used to print in full colour. The letters stand for Cyan, Magenta, Yellow and Key. The final colour is actually black but the term 'key' is used because it refers to a key plate used in printing, normally with black ink. In theory, using cyan, magenta and yellow should result in black, but as the pigments aren't entirely pure, without black the result would be a dark brown. CYMK differs from RGB as it's a subtractive colour mode. This means is that the print starts at white and by layering inks the process subtracts the reflected light until it produces the desired colours. Unfortunately current printing technology doesn't allow for as many colours to be printed as the computer screen can render. As a result, computers use what is known as a colour gamut, this is a subset of the colours available that can actually be printed.

## Timesaver tip

Many of the most commonly-used print ratios are already included in a drop-down list, which appears in the top left corner once you have chosen the Crop tool. Simply press the arrow to the right of the symbol and pick from the list.

## Crop your photos ready for print (cont.)

**10** Finally if you want to rotate the area being cropped slightly for a better match to your subject this is possible too. You need to hover the cursor just outside one of the cropped area's corners – this will switch the cursor to a small arch with arrowheads on it. At this point, if you press and hold the left mouse button you can manually spin the area being cropped – ideal for lop-sided landscapes.

**11** Remember that cropping your photos can produce a similar effect to using the camera's built-in digital zoom. With this in mind, don't crop too aggressively as the quality of the final print is likely to suffer.

**12** Once you have the images adjusted for printing, don't save them over the originals. After all, if you change your mind about how you trimmed the image and you had done that, there'd be no going back.

4

# Add frames to images

So you've captured an image you're happy with and edited and tweaked it to improve on it further still. What you need to do next is put it in a frame, but you don't necessarily have to buy mounts or a razor-sharp craft knife, you can make an attractive frame right here in Photoshop. The presentation of an image can dramatically affect the way people react to it, even simple touches such as the addition of a white border can make an image much more appealing. Frames can even be used to visually link a series of photographs. This task will look at how to edit your photos to include simple touches such as borders or more advanced effects like a drop shadow effect.

**1** Begin by opening one of your favorite images in Photoshop. This will be the first photo to get your special attention.

**2** Once the photo is loaded, find the Layers panel on the right-hand side of the display and right-click on the bar marked Background. This will open with a context menu with numerous options, one of which will be Duplicate Layer, click this.

**3** After you have done this, a small box will appear asking you to name the copy being created. Feel free to give this any name you like but by default it will simply be called Background Copy.

**4** You will now notice on the Layers panel that you have two identical layers, one marked as Background the other Background Copy.

## Add frames to images (cont.)

**5** The Lower one should be the Background Layer, select this and move the cursor to the top menu bar. Next click on Image and then Canvas Size.

**6** The quick and sloppy way to create a border is to simply switch the controls over to percentages and type in 110 or 125%, Instant Border. However you'll notice that this creates a border that is thicker on the sides than it is top and bottom or vice versa. This is because the border sticks to the ratio of the photo.

**7** The best way to create an attractive border requires a little more thought. As we discussed in the previous chapter, you need to crop your image to fit a print size, but if you intend to incorporate a border you also need to think about your preferred border width. Multiply that figure by two and take that off the value you crop by. For example, if you want to create a 10×8 print but you would also like a one-inch border on all sides you need to crop the original photo to 8×6.

4

# Add frames to images (cont.)

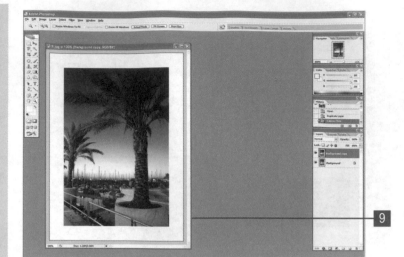

8 With your correctly cropped image you can leave the Canvas Size variable in inches. Make sure the Relative box is not ticked and type in the total size of your final print. Beneath these numbers you will also notice nine squares with arrows all pointing from the centre. This represents where the image will be situated after the addition. By default it should place your image dead centre.

9 Once you have typed in your border width, press OK. If you did the simple bit of maths correctly, your photo should now sit in the middle of a perfect border.

At this point you can consider how you want the border to look – popular designs usually employ either a thin border to simply enclose the image; a thick two-inch border to give the photo a sense of importance or the variation known as a 'gallery border' where the bottom is typically twice as deep as the remaining three sides. Remember that when selecting the size of the canvas you can also alter the colour – sometimes using a black border can be much more striking.

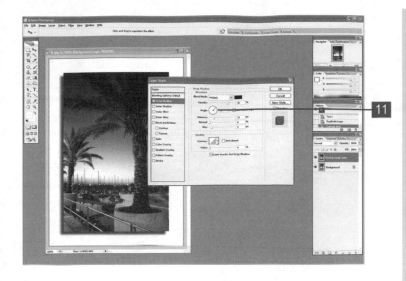

**10** If you want to add some extra effects to your image you can also try adding finishing touches like a drop shadow. To do this, simply select the background copy in the Layers panel. This should become the top layer, then right-click the copied layer and choose blending options from the context menu.

**11** Amongst the options available is the Drop Shadow tool. To use this and make any adjustments to the effect, you first need to left-click the option itself. By doing so the box to the left of the text should be ticked. Here you can control the direction the shadow falls, how far it spreads and even its colour.

**12** If you want to add a textured frame this is relatively easy too. Select the background on the Layers panel again then click the Fill symbol on the tool bar. This will provide a number of new options along the top of the screen. The first on the left will typically read Foreground – choose the drop-down menu and instead select Pattern.

4

# Add frames to images (cont.)

**13** Next click on the sample box beside this drop-down menu and choose your preferred texture, if you can't see anything you like, click the arrow pointing to the right to open a context menu. Here you can select additional patterns to load. Why not have a look at the rock patterns?

**14** Once you pick out a design you like, click the Fill tool in the empty border to create your designer effect.

# Creating a digital album and archiving your images

## Introduction

Before we look at how to print our images we need to ensure all our digital photos are safe and secure. It's all too easy to take literally thousands of images and never back them up, storing all our photos on one computer just to have every memory of children growing up, your brothers or sisters getting married off and that once-in-a-lifetime holiday disappearing behind a dispassionate error message telling you that they are corrupted and gone forever. In this chapter we will look at ways of safeguarding your memories, retrieving images from failing memory cards and new ways to archive and enjoy your images in an age where simple albums aren't the only alternative.

## What you'll do

**Burn to CD or DVD**

**Create a CD cover**

**Make an attractive slideshow**

**Recover lost images**

**Understand portable Image storage**

## Burn to CD or DVD

The most effective and commonly used method of backing images or indeed any data up is to write it to either a CD or DVD. The term burn or burning is used as a laser is used to burn the data on to the optical disk. There are various different types of disk available and this task will try and highlight the choices you have when it comes to media. We will also look at how to lay out the information on the disk for different destinations – how you burn a disk to take to a kiosk will differ to how you back up your albums.

**1** First of all you need to determine whether or not your home computer actually has a CD or DVD writer built into it. Typically if you use a desktop PC this will be on the front of the computer, if you have a notebook it's more likely to be located on the side.

**2** If your drive has a tray in which to load the CD or DVD have a good look at what is written on the front – it needs to say something along the lines of Compact Disc Rewritable or DVDR. However, if the drive only mentions CDROM or DVD with nothing coming after that, you may have to shell out on an upgrade.

**3** If you're still unsure as to whether you have a CD or DVD writer, putting a blank disk in will prove it either way. The issue is which disks you need. Brandwise, the choice is entirely yours, however we can give you direction as to the right type for differing tasks.

## For your information

### You don't have to print your pictures

It's said that a picture can convey a thousand words and it's certainly true that wading through a friend's holiday snaps, no matter how adventurous, will have you feeling like you need to get away. However there are new ways to share your photos, you don't even need to print them. You may not be aware of it but many households already have a perfect way of enjoying images right there in their living room in the shape of the DVD player. Your DVD player doesn't have to cost a fortune indeed the least expensive are often amongst the most versatile. So long as your player is capable of playing back JPEG files you could sit back and enjoy a slideshow of your digital photos. That way you and your friends can dip in and out of the photos, and if you feel the need to ask exactly why they were balancing a stack of tumblers on their head you can.

5

5

**4** If you want to take images to a photo developer you need the disk to be as widely compatible as possible, for this we would suggest a CDR. You will see different disks such as 74mins and 80mins – either will do. CDR disks can be written to in stages but it's *not* possible to erase at all.

**5** You will also notice that there are disks known as CDRW, these offer the same amount of storage as CDR but offer the additional benefit of being completely rewritable. This could be useful if you were editing photos in different locations, but there are better, more portable solutions such as USB keys.

**6** In most good digital camera shops you should find a selection of blank DVD disks nestling in amongst the CDs. Just like CDs you have disks that can only be written to, namely DVDR, and rewritable disks namely DVDRW. There are also two competing formats known as plus or minus and you need to be sure which your drive supports. On a positive note for the last couple of years most drives will accept both.

6

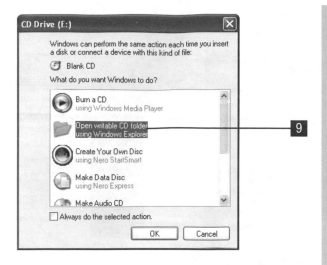

**7** DVDs can be useful for storing large amounts of data making them ideally suited for backing up entire albums. However, at present very few photo developers actually support them so if you really need prints you'll still have to burn them onto a CD. Also if you're using a Windows XP computer you'll need to buy additional software such as Ahead's Nero package to use blank DVDs.

**8** Now you've selected your media, we need to get down to the business of backing up. Start off by loading your disk into the drive, with the writing facing up.

**9** Depending on your computer, the rest of this task may differ, so first of all, if you use a Windows XP-based PC a menu will appear acknowledging that a blank CD has been loaded. Among the selection available should be Open Writable CD Folder using Windows Explorer. Select this and move your chosen images or data into this window much as you would when copying and pasting files.

## For your information

For those of you using Adobe Photoshop there is an excellent feature built into the application called Contact Sheet II. This tool can be accessed by clicking on File then on the submenu, Automate. This will open another submenu in which you can select Contact Sheet II. Once you have opened the Contact Sheet tool you first need to tell it where to collect the images from and in turn where you want the new Contact Sheets output to. If you start the process running it will create a page full of your images in thumbnails ideal for keeping with your CDs or DVDs to show what is on each disk. The clever ones among you will also notice the Contact Sheet tool allows you to specify the dimensions of your page and if you type in 4.75 x 4.75 inches you can make a CD cover with your thumbnails directly on it.

5

# Burn to CD or DVD (cont.)

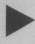

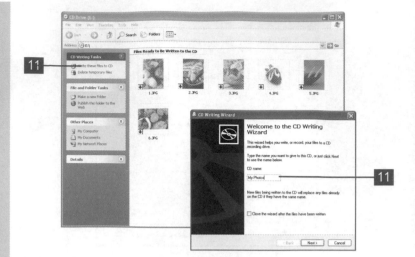

**10** Once your images have finished copying across, the disk will appear to have finished. However, let's not get too excited, at this stage nothing has actually happened.

**11** If you read the options on the left panel you should see the text, 'Write these files to CD'. Click on this and it will ask you to name your CD – it will default to using the current date. Type in your preferred name and click Next to continue writing your CD. If you like you can kill the next couple of minutes watching the progress meter and when it's done, click Finish and breathe a sign of relief – you've just written your CD.

**12** Mac users, we haven't forgotten you! In fact, life for you folk is considerably easier. Start by popping in the blank disk, for OSX Mac users you can use CD or DVD.

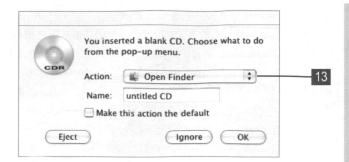

**13** Once it recognizes the empty disk it will bring up a menu, here you should select Open Finder. This should bring up the standard finder window. If it doesn't, simply click the new untitled CD/DVD icon on the Desktop.

**14** You can now drag your images or data into this new window and when you're finished, press the Burn button in the top right.

**15** Finder will then ask you what speed you want the disk to write at and what name you would like to give it. Click on Burn again and the disk's progress will appear on screen.

**16** When it's finished, it will return you to the Finder and your newly-created disk.

5

## Create a CD cover

Correctly labelling any disks you create might not initially seem all that important. After all when you only have two disks, it's a fifty-fifty chance you're going to get what you're after. However a couple of months down the line wading through hundreds and hundreds of blank silver disks can be as mind-numbing as the reading material in a dentist's waiting room. By labelling and dating your CDs it can be much easier to recall where the exact image you want is. However, nothing beats having the images themselves on the sleeve of the CD. In this task we will design our own cover using sample shots from the CD. There are numerous applications you can use to create CD covers but here we will look at Adobe Photoshop once again.

**1** Step one requires that we download a small file from the Internet which automates much of the task, this can be found on the following website: http://thepluginsite.com/resources/gizmo/. This simple action file can be used on both Apple and Windows PCs.

**2** Once you have downloaded this Zip file, you will need to open the compressed file up and save the contents in the Photoshop Actions directory. On a Windows system this will default to C:\Program Files\Adobe\Adobe Photoshop CS2\Presets\Photoshop Actions whereas on an Apple it is more likely to be Photoshop\Presets Photoshop Actions.

**3** After saving the downloaded action files to the correct location, open the Photoshop program. When Photoshop has finished loading, click on the Actions tab on the left of the workspace, this will bring this menu into focus.

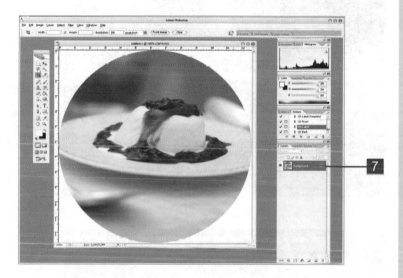

4

7

4 Next press the small arrow to the right of this tab, which should open a long menu bar. On the menu, click Load Actions. This will open a familiar Load menu. At this point you need to select CD_Utilities and click Load.

5 Now if you scroll down the list of Actions there should be a new option named CD_Utilities. This in turn can be opened to show numerous new tools.

6 For example, open one of your recent images included on your backed-up CD. When you have the image on screen, highlight CD Front and along the bottom of the Actions menu press the Play symbol. This will start the automated action, which will create a new document. You're offered the option to name it when it's finished. It should create a CD front cover in the correct dimensions to be printed.

7 You can also create the back cover and the CD label itself in the same way. Just open an image and press the corresponding action. If you also wish to label the covers, simply press the T icon and then type in your text.

5

# Make an attractive slideshow

Previously we looked at using your DVD player to run a slideshow. This is a very effective way of seeing your photos up on a big screen, but with no music or effects the experience can fall quite flat. In this task we will look at how to increase the production value of your slideshow by adding music, digital effects, titling and even a DVD-style menu. This may all sound very complicated but we're going to use the Magix Movie Edit Pro application which automates much of the process. This application is designed for Windows use only, but Apple's iMovie operates in much the same way.

**1** First of all we open the Magix application. This brings us to a time line screen which initially will be empty.

**2** In the middle of the screen there will be a button marker timeline that toggles the display back and forth between the simple and complex views. Ensure that you are in the simple mode by having this button in grey rather than illuminated in red.

**3** The timeline on the bottom half should now resemble a flatten roll of film. On the top half you will have a screen to preview your video and a series of tabs offering effects and directories full of your images or even video.

**4** To select the images you wish to include on your DVD, press the My Pictures tab. This will show you the contents of this directory and allow you select any images you want. You can add images from directories other than the My Pictures folder but you will need to browse to them by clicking on the drop-down menu to the left of the location.

**5** Next, simply drag the images one at a time into the lower portion of the screen, or alternatively press and hold the left mouse button to drag a box around multiple images and drag them all at once to the timeline.

**6** Once in the timeline, the images can be easily rearranged by clicking and holding on an image then dragging it to its new position in the sequence.

**7** You will also notice that the duration each image is on the screen can be controlled by adjusting the value under the it. Don't worry about this too much, however, as we will rely on the software to adjust it for us.

**8** Before moving on to add music and effects we need to ensure the red vertical marker in the time line is right back at the beginning, otherwise any music we add will come in half way through.

5

# Make an attractive slideshow (cont.)

**9** We can tailor the video to look more professional by pressing File on the menu bar, then selecting Movie Show Maker. This menu is designed to simplify the process and comes in three steps.

**10** First you select the style of video you would like from a wide array including '70's party', 'Photo Album' and 'Cutting and Soft Blending'. For this task, click on Cutting and Soft Blending.

**11** In the second section you can opt for a series of built-in accompanying music tracks. If however, you have your own music you would like to include, you can press on the yellow folder at the end of the current file's location. This will bring up a familiar browse box and you can simply find the music you want to include. Once you have done so, click OK. Remember that if you change your mind about the music you can simply repeat this stage and pick again.

**12** The third portion of the menu allows you to control the speed of the sequence. We would suggest if it isn't already checked, then click on the 'Adapt the length of movie to music' box. By activating this option, the music will synchronize better with the photos.

**13** At the bottom of all three sections you will see a red box with an eye in it. Pressing this will set the computer off creating the movie, you will then be able to see a preview on the panel to the right.

5

# Make an attractive slideshow (cont.)

**14** If you wish to add credits you can do so by checking the Choose Own Credits option then clicking on Edit Credits.

**15** When you are happy with the results press Apply. This will drop you back to the simplified timeline. If you want to double-check your work so far you can do so by pressing Play on the preview pane. This will give you an accurate representation of how it's coming together.

**16** In the top left of the display you will notice two tabs, one reads Video Editor, the other CD/DVD editor. To burn this video to DVD select the CD/DVD editor option. This will switch the whole display into a preview of how your DVD will look. Along the bottom of the display are numerous templates for different example styles like the Movie Maker – simply select whichever appeals.

**17** As well as being able to alter the appearance you can also change any chapter titles by double-clicking on them with the left mouse button.

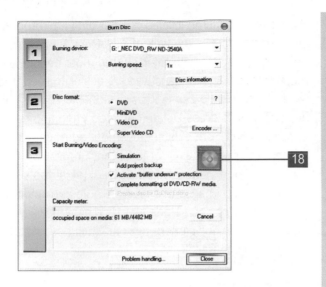

**18** When you are happy with the overall DVD, you can burn a copy by clicking on the Burn Disc button. This will first of all, save your project to ensure you can quickly make more copies, then it will present you with several DVD writing options – the default values should be fine. When you have put a blank DVD in the drive you can start the disk off by pressing the red button with a DVD on it.

**19** The process will go through several stages and on a longer slideshow can take over 30 minutes. At the end, a notice will pop up saying that the disk is finished – clicking this will eject the completed DVD. Congratulations! You have made your first photo DVD.

5

# Recover lost images

One of the criticisms leveled against digital photography compared to film is the lack of negatives. By having a physical object to associate with their photos most people feel they are more secure because negatives are easier to keep track of and harder to lose. In a sense it's a reasonable suggestion as it can be very easy to press Delete once too often and have your best images erased from existence without so much as a footprint to mark their passing. Or at least that's how it would appear if you didn't know better. This task will look at tools used to restore deleted images or repair a whole corrupted card. There are a number of good Undelete packages on the market, you may even find your camera package includes one. Here we will be using Image Recall.

1. First follow the install instructions for your software. Once it is completely installed, open the program. In the case of Image Recall this will bring you to a Drive Selection screen.

2. If you use your digital camera with a flash card reader, remove the memory card and insert it into the correct slot on the reader.

3. Alternatively if you simply connect the camera directly to the computer, ensure that your batteries have sufficient charge, then connect up your camera as usual.

2

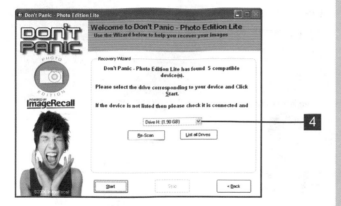

**4** Once you've waited for your computer to acknowledge the card or camera, use the drop-down menu to select the drive letter for the memory card that contains the deleted images or corrupt files.

**5** With the appropriate drive selected, start the software scanning for files. On the Image Recall software this is represented by a magnifying glass. Remember this package is very thorough and will also find images that you intentionally deleted, so maybe don't start this program with an audience?

**6** After starting the scan running, you will see a bar steadily moving across the screen to indicate the progress of the recovery. Above this all of the retrieved images such as JPEG and TIFF files will systematically pop up on the display.

5

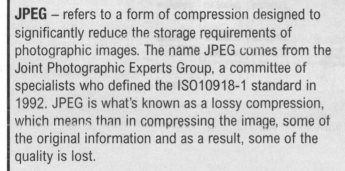

## Jargon buster

**JPEG** – refers to a form of compression designed to significantly reduce the storage requirements of photographic images. The name JPEG comes from the Joint Photographic Experts Group, a committee of specialists who defined the ISO10918-1 standard in 1992. JPEG is what's known as a lossy compression, which means than in compressing the image, some of the original information and as a result, some of the quality is lost.

# Recover lost images (cont.)

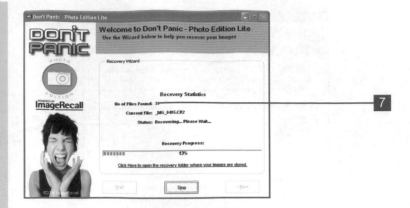

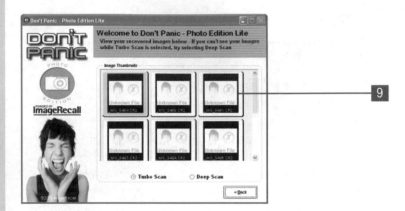

**7** While the scan is running you will also notice in the corner a record of how many read errors the card contains. This number is important especially if the loss of the images was due to memory card failure. One or two could mean the card was removed whilst still writing and a simple format of the card will solve it, several hundred and you should probably consider replacing the card.

**8** At the end of the scan process, Image Recall will ask you if you wish to view the files it found, press Yes.

**9** Thumbnails will then appear to give you a quick reference to the photos Image Recall was able to claw back from your memory card. Above the photos there is the option to see the recovered files. Pressing this will take you to their location on the computer and allow you to copy them wherever you want.

## Jargon buster

**TIFF** – stands for Tagged Image File Format and works in a similar way to JPEG. TIFF, however, can compress photos without any loss of quality, also TIFF files have the advantage of being able to support layers. As a result, while some digital cameras do support TIFF files it's far more likely you will encounter TIFF files while using a photo editing package.

# Recover lost images (cont.)

10 The package has a number of useful additional features but perhaps one of the more sensible is the ability to write to CD or burn a recovered file to CD as it is labelled.

11 By selecting this option you can ensure your images are safe and secure on a separate disk as well as a CD, giving you peace of mind if your computer were to fall victim to a virus.

5

# Understand portable image storage

Anyone who grew up using a film camera will enjoy the freedom digital photography allows, primarily the ability to view your images immediately and discard any you are not happy with, but also the sheer number of images you can capture. Gone are the days when you took 24 or 36 exposures with you were on holiday. Now you can take literally hundreds of images. Some people, however, find even this can be restrictive and this is where portable storage devices come in. If you're embarking on a world cruise, backpacking across Asia or enjoying some other prolonged period of travel where carrying lots of memory cards might be an expensive solution, these devices adopt a similar approach to photos as iPods do to music. They allow you to store literally thousands of images in virtual albums which can, in some cases, be reviewed on the built-in screen or hooked up to a television.

When selecting what portable storage device suits you best, remember they can vary pretty widely with the simplest being little more than a hard drive with a memory card reader bolted on. The most powerful may be only marginally less powerful than a full-blown laptop. Obviously your budget will dictate where on the scale you buy in.

The entry-level devices typically feature a simple monochrome LCD screen designed to show only the essential information such as the amount of used and free storage, and the progress of any memory card transfers.

In most cases, to begin the process of backing up your photos, you only need to press a transfer button. Do remember though, never to remove the memory card or turn off the storage device until the data backup is complete.

The drawback to these entry-level devices is that without a proper colour display you can't see your photos until they are transferred off the device. Obviously by then you may have reused the card and it would be too late to recover the images.

If your budget extends to one, you could try one of the lalest generation of purpose-built photo viewers. These higher-priced models not only allow you to scan quickly through any of your images stored on the device, but they can also be connected to external displays or printers, without requiring a computer.

When considering what type of storage device to purchase, the most obvious consideration is the capacity. The current crop of portable storage devices come in a multitude of storage capacities ranging from 20 to well over 40 gigabytes. Aside from the sheer size of the storage you should also look into the formats the device supports, such as JPEG, TIFF and RAW files.

Before committing to any of the more expensive devices, request an opportunity to see how clear the display is and how long the device takes to move between each image. You'll find you don't bother to use it regardless of how clear the screen is if it takes over a minute to load each photo.

Lastly, remember that these units are used away from home so check how long the batteries last. This could make the difference between a backup device and a brick.

5

# Getting real prints from your digital images

## Introduction

So far we've examined how to improve the way you capture your images, and provided you with simple techniques to tweak and enhance the way your photos appear. In this chapter we will look at ways you can commit your images to print. Whether you prefer the convenience of printing at home, the simplicity of an online developer or want to create a modern-day masterpiece to adorn your living room wall, this chapter will take you through all the information you need to get your work out of the camera and into your hands.

## What you'll do

**Print at home**

**Use online developers**

**Use a digital kiosk**

**Get poster prints or canvases**

# Print at home

For many the easiest way to get a hard copy of their prints is their colour printer. Depending on the suitability of the printer the results can obviously vary dramatically. If you are using a standard ink or bubble jet printer with only three colours the likelihood is that your photos will fall far short of the quality you would expect from a high street developer. The problem is that recreating paler skin tones or subtle colours can only be achieved by putting less ink on the page and this has the effect of making the image look very grainy. The latest generation of photo printers however, often have up to six or even eight different inks or pigments designed specifically not only for accurate reproduction of photos but for longevity of the print, so the results will look as good in ten years' time as when you first printed them.

## Direct printing via cable

**1** First we need to load the photo paper into the printer. It's generally suggested that you buy the same brand of paper as you buy inks as this means that the way the inks bond to the page is predictable and you should get the best results. For this task we will assume you have a printer designed for photo reproduction.

**2** Next look for the word Pictbridge on your printer. This means your printer and camera can talk to each other directly without necessarily needing to be used in conjunction with a home computer. In fact many of the smaller 6x4 printers can not only be used directly from the camera but often have provision for battery power, making the whole solution very portable.

**3** Aside from just taking photos, many digital cameras can also be used as webcams or simple storage devices. In order to ensure the camera is in the correct mode, go into the setup menu. This is typically accessible by rotating the mode dial to Setup or simply pressing the menu button and scrolling to the Setup option.

**4** You should find an option that refers to USB or interface. Toggle through the options until you find PTP, PICT or Direct Print. These options allow the camera to control a similarly equipped printer.

**5** Next we need to switch the camera into Playback mode, ready to be connected to a printer. It's a good idea before connecting the camera to scan through the images to find the photo you wish to print.

**6** Find the standard USB cable that came with your digital camera for connecting to the computer and instead, connect this directly between your camera and the USB socket on the photo printer.

### Timesaver tip

Refill inks are often much cheaper than the genuine article. However, their use can affect your printer's warranty and they also can produce inconsistent or unexpected results with branded paper.

# Print at home (cont.)

**7** Once the two devices are connected, they should react to indicate communication between the two. In most cases the camera screen will change and display a simple array of print options, typically including how many prints you want, making an index print, adding a time stamp, or on more advanced printers, the ability to crop out a small portion of a photo to be printed.

**8** Pick out one of your favourite images and select one print from the camera menu.

**9** Once you have your final print, it's best to situate it away from direct sunlight and under glass in order to ensure that the colours remain strong and don't shift. By enclosing the print, the pollutants in the air are less likely to interact with the inks.

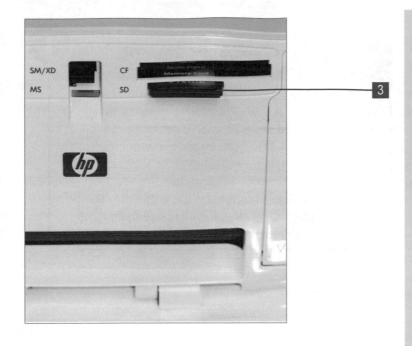

### Direct printing via memory

1 Being able to connect your camera directly to the printer greatly simplifies the process of printing but it isn't without its drawbacks. By connecting up your camera to make your print, your batteries are being run down the whole time.

2 If your printer comes equipped with memory cards slots it's also possible to insert your camera's media directly into the printer. Turn off your camera and remove the memory from the slot. Note that many memory cards are spring-loaded and must first be pushed in before you can remove them.

3 Next find the corresponding memory slot on the printer. Ensure that the memory card is the right way round before pushing it into the printer. It's unlikely the card will be difficult to insert so if it's not going in, check you have it the right way round.

# Print at home (cont.)

4 Once the card is correctly installed, the printer should indicate the pictures are being read. Printers which are geared to print photos typically feature a small screen, much like the display on your digital camera. This enables you to select which images you wish to print. It may also show more detailed directions.

5 Next using the printer's controls, select the image you wish to have printed. Once you have found the desired image, you should be presented with numerous options including the size of print required and number of prints.

6 Use the printer's menu to select one standard 6x4 print. This should start the printing process.

7 As before, keep your print away from direct sunlight and under glass. Enclosing the print protects it from airborne pollutants which might discolour the inks.

2

## Use the computer to print

**1** Printing directly from a photo printer is extremely straightforward but doesn't give us much flexibility. For edited images we need to hook the printer up to a computer.

**2** To do this we need an A to B USB cable. Unfortunately these don't come supplied as standard when buying your printer so make sure you ask for one.

**3** Look at the USB cable: one end will be square the other rectangular. Take the square end and plug this into the printer, next take the rectangular end and find a spare socket on the computer. It doesn't matter which one you pick as they all work the same way.

**4** The printer should come with a driver disk. Simply follow the accompanying instructions to install this software – which tells the computer how to communicate with the new device. If you have previously installed the software you don't need to run it again.

# Print at home (cont.)

**5** After the software is installed, load the printer with A4 photo paper.

**6** Next open one of your photos and click on File from the top menu, this will open a drop-down menu and you should be able to select Print with Preview.

**7** If you use an application such as Photoshop you will be presented with a new screen with lots of information about how the photo could be handled. On the left is a picture of your photo and how it will appear on the page.

**8** To alter the size of the photo first ensure the centre image box is checked, then type in the size you wish to print in the height and width boxes. For this task choose 6x9 inches. Should you wish to use the entire page simply check the Scale to Fit Media box.

## Jargon buster

**TWAIN** – before 1992 getting your scanner to talk to your PC or have your application actually acknowledge its presence it could be a very hit and miss affair – that was before TWAIN became established. Despite not officially being an acronym TWAIN stands for Toolkit Without An Interesting Name, and is the industry standard for communication between scanners, printers and applications.

9   If your image uses a landscape ratio, simply press the Page Setup option and switch the page from portrait to landscape, before pressing OK.

10  Next, press Print. This will then open the printer's own settings menu. Every printer shows different options but typically you must press Properties to access the current print configuration. Ensure the paper size is correct and the quality is set for photo.

11  When you've confirmed the settings, press Print. This will start the computer sending the image to the printer and begin printing your photo.

## Use online developers

1 Open a web browser and type in the address of your chosen online developer.

2 Most web-based developers require that you become a member of their site before they will allow you to start adding your photos. You shouldn't have to provide many more details than your name, address and e-mail address.

3 You will also be required to select a password. Try to make this memorable but not something that is likely to be guessed easily.

Anyone with an eye for a deal will understand the attraction of using one of the growing number of online developers, with prices that significantly undercut the high street competition. The only reservation is usually that of quality. Indeed with high street stores it's easy to see the results for yourself, and if things go wrong you can give them a piece of your mind. With an online developer, how can you trust that the prints will come out any good? Most of the larger online developers try and put your mind at rest by providing free samples of your own images. This practice gives you an opportunity to evaluate not just the print quality but the simplicity of selecting and uploading your images as well as the speed at which they deliver. For this task we will be using a company called PhotoBox who also operate professional photo galleries. However, there are many reputable alternatives.

**4** Once you have signed up you should then have the ability to add or remove images from a web-based photo album. Using PhotoBox, the option to add photos is located on the top of the page, by selecting this the computer downloads a tiny application. This may prompt your computer to issue a security warning. In order to proceed you will need to allow this software to install.

**5** Once installed, the web page will change and present you with a three-step guide to transferring your photos. The first stage is deciding in what album you want your photos to be saved. This allows you to categorize your images making them easier to find later.

**6** The next step is to pick out which photos you want to transfer. You can go about this one of two ways, either by selecting individual images or the complete directory in which they're stored. Remember you can only select JPG or TIFF files, RAW files won't be accepted.

---

## Jargon buster

**RAW** – when digital cameras take a photo they process the image to convert it to JPEG or TIFF, making decisions as to how sharp you want the image, how much colour you want and what level of compression you would like to employ. Unusually for an electronic term, RAW isn't an acronym. It simply means raw or unprocessed. Choosing to use RAW files means you tell the camera to leave the images alone, allowing you to make these decisions later when you convert the images on your computer.

# Use online developers (cont.)

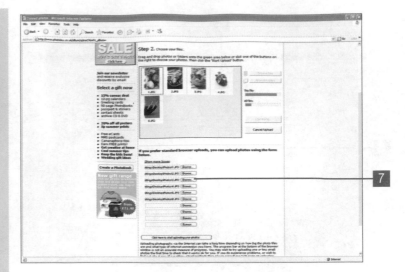

7

**7** The last step in uploading the images is to press the Upload button. This then sends your collection of images over to the online developers. After you press the upload button there will be a short delay as the images are transferred, the more images you select the longer this will be.

**8** Once the upload completes, the website will display a confirmation screen showing you the images uploaded. Just beneath this confirmation you will also have the option to purchase prints of each image in a variety of sizes.

**9** If you want to make up an order with both new and old images, simply press the My Albums option which will give you access to everything you have uploaded to date. You can then pick any images and view them in more detail, delete them or add them to an order.

**10** Remember that besides the size of the prints, you can also select your preferred finish. Some online developers also make provision for borders to be added.

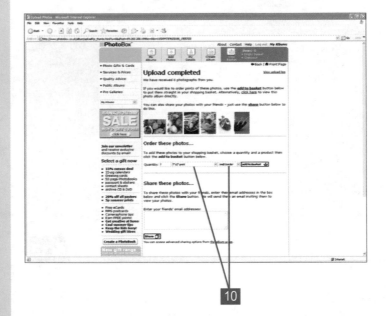

10

**11** After you have chosen the images you want printed, quickly check your basket which will list your selection and show how each image is going to be printed, complete with any crops.

**12** If you've selected a size which doesn't fit the image completely the thumbnail will have a red box surrounding the area that is going to be printed. This is your opportunity to either select a different size or move this box to ensure it prints the elements you want.

**13** After making any changes you deem necessary, continue to the checkout and enter your payment details.

**14** Keep an eye open for how your prints are packaged when they arrive, a good developer should provide a sturdy card envelope to ensure your prints arrive undamaged. If your prints arrive in an ordinary manila envelope you would be advised to spend your money elsewhere.

# Use a digital kiosk

In the past taking your last exposure and hearing your film wind back was a momentous occasion signalling the first opportunity to get your photos developed, and finally get your hands on all those images that in your mind's eye at least were so full of potential. Potent images of celebrations, weddings, births or holidays in the sun await. All you had to do was hand over your roll and select a size. If you were timid you could even ask to have the film taken out of your camera. With digital cameras the possibility of seeing your photos immediately has taken some of the magic out of the equation. However, what they do add is another level of choice, aside from picking out the better photos you can even tweak the composition to refine them further. This task will take you through using a typical digital kiosk.

1 For this task you will need to get your images to a photo developer. You can bring the whole shooting match along including the cable, a CD of the images you want printed or if your camera has removable memory you can choose to take just this.

2 If your camera doesn't have removable memory and you choose to take the camera to the developers, remember to take your USB connecting cable otherwise you'll be making a return journey.

3 Once you're at the console most systems are touch-sensitive, so to start the process simply touch the screen.

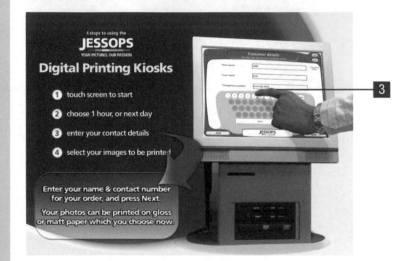

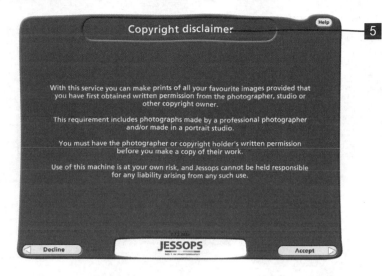

**4** Don't worry about making mistakes you can always start again. If you order too much simply ask at the counter for cancellation of the order. Finally, don't fret about the potential to delete your images – typically kiosks don't offer a deletion option.

**5** Typically, you will then be presented with a rather lengthy legal document. You should read and agree to this, but it you want the edited highlights, basically it requests that you respect the copyright of professional photography and don't start duplicating other people's work and that, obviously, your images should also be fit for public scrutiny.

**6** Assuming you can, in good conscience, agree to disclaimer, press the appropriate button.

### Jargon buster

**Memory stick** – different camera manufacturers often use different memory formats to store their images. Memory Stick is Sony's answer to the problem. Memory Stick itself has numerous different physical formats with PRO, DUO and now M2. Predictably each new format is smaller than the last with increasing storage capacities and higher transfer speeds to enable smoother video or faster burst speeds.

# Use a digital kiosk (cont.) ▶

**7** Typically the next screen will then offer you the range of services available, for example 1 hour and 24 hour printing. More recently, some of the larger chains of photo developers have even been selling photo gifts ranging from the predictable – like mouse mats – through to the more esoteric, like wrapping paper and teddy bears wearing photo printed t-shirts.

**8** After selecting exactly what you're after, you will then be asked to insert your media. At this point, either slide in your memory or CD. If you have any concerns about handling the memory ask for some assistance. Most memory, however, is very resilient.

**9** If you camera doesn't have any removable memory you should, at this point, connect the camera in exactly the same way you would at home – the kiosk is after all just a customized home computer. You may even hear the characteristic acknowledgement sound as your camera is recognized and the images are retrieved.

## Jargon buster

**CompactFlash** – as one of the oldest memory formats, CompactFlash is also one of the largest. This physical size means manufacturers no longer provide support for it in compact digital cameras. In the professional arena CompactFlash remains a firm favourite and is used in nearly all DSLR cameras.

**10** After the images are downloaded from your media or camera, the kiosk will request that you type in your personal details – these normally consist of your name and contact number. Don't worry, this information isn't going anywhere. The kiosks just add your name to a printed slip at the end which is used to match up with the photos. When you've typed in your details, press Next.

**11** Although the next screen differs from kiosk to kiosk you should be shown miniature versions of your photos – these are referred to as thumbnails. You will then need to pick out the images you want to have printed. To do this touch the images you want, they will be circled with a red band.

# Use a digital kiosk (cont.)

12 Although at this stage you will have numerous images highlighted on the screen, you haven't actually selected anything yet. It's not until you choose the print size you want, that they are added to the order.

13 As you select the size of your prints you should see a running total increasing. When you're sure you have included everything you want, finalize your sale by pressing Checkout.

**14** Again, different kiosks will present you with different choices, but generally you should be offered the option of having your images written to a CD. This is a worthwhile addition as it serves as your equivalent to negatives and if your computer was to break or worse get stolen you would still have your memories.

**15** If you choose to write a CD, be prepared for a five-minute wait as the disk writes. After this, the kiosk will print you a ticket. In some instances you are required to pay via a card on the kiosk itself, while others leave that to the shop staff. Either way your work here is done, now you just have to kill some time.

## Get poster prints or canvases

Now that you've set up your online developer, we can advance to creating some much larger images. For a poster or canvas to look effective, the original image needs to be at the highest resolution your digital camera can offer, otherwise any imperfections will be magnified. When you are creating a canvas, you also need to consider how much of the image will be wrapped around the edge of the frame. With a little planning this can look extremely effective but get it wrong and the canvas could be a write-off. In this task, we will revisit our online developer. However, if your chosen developer doesn't offer poster or canvas printing there are specialist companies available such as Gaskin Images.

**1** Open a web browser and type in the address of your online developer.

**2** When the page has finished loading, if you haven't previously registered, you will need to enter your personal details before you can upload any images. Otherwise, click on the Log On button and type in your e-mail address and your password.

**3** Once you have successfully logged in you will be presented with your digital album. Obviously if this is the first time you have signed in there will only be an empty album.

**4** If you intend to create the canvas from an existing image simply open the appropriate album. Otherwise, to add a new image, press the Add Photos option at the top of the page.

## Get poster prints or canvases (cont.)

**5** To upload your new image, choose the destination album then select the photo to be uploaded. When you click Upload File there will be a delay before the website acknowledges receipt of the file. It will then drop you back to the list of albums.

**6** Next, open the album containing your new image and select the size you would like the canvas to be. You need to consider the ratio of the image as choosing the wrong ratio will mean the image needs to be cropped in order to fit.

**7** Before proceeding to the checkout, press the View Basket option. This allows you to check your order and if cropping is required, you can manually select the area you wish to be used.

**8** Once you have the canvas the way you want it, press Checkout and provide your payment details. Unfortunately canvases aren't next-day delivery and you'll have to wait for your masterpiece to arrive for around two weeks.

# Making money from your photos

## Introduction

Once you start getting more confident in your abilities there's no reason why you can't show your image off. In fact with digital photography, you can create your own gallery of work straight on the Internet. In this chapter we will guide you through the dos and don'ts of handling your images, any legal implications you should consider when taking and sharing your images and precautions you can take to stop others from claiming your work as their own. As we said before, photography is a great deal of fun but in this chapter we will also look at ways you can help to make the pastime profitable as well as enjoyable.

## What you'll do

**Know your rights and responsibilities**

**Watermark your images**

**Use stock libraries**

# Know your rights and responsibilities

The pastime of photography has always had its detractors. However in an age where you can be challenged for simply holding a camera in the proximity of children, airports or national monuments you need to be very mature about how you conduct yourself, and be well versed in the legal boundaries of what you can and can't do. In this section we will look at the law as it stands and describe some ideas to avoid potential pitfalls. If you wish to investigate any aspect of the law and how it impacts on photographers you would be well advised to seek out a copy of *Beyond the Lens* – produced by the Association of Photographers – as this provide the most comprehensive and up-to-date guide.

First-off, some of the good news – if you take a photograph the copyright is automatically yours. As a professional photographer this is still true even if you have an assistant actually pressing the shutter. However if you are employed by a company, the business owns the copyright, meaning if you leave the images are theirs.

Photographers who work under contract can choose to retain or relinquish the copyright. As a rule of thumb, try and keep the copyright and instead issue the contractor with a licence to print a finite amount. The copyright of your photographs continues for as long as you live plus a further 70 years, making them potentially a great inheritance.

If you intend to sell your photographs, be very careful what you include in your images as brand names or artwork are copyright and could land you in hot water. However while architecture and sculptures could be equally recognizable, as long as they are permanently situated somewhere open to the public, you are free to photograph and reproduce images of them.

When photographing people, always try and get them to sign a model release. This doesn't have to be a massively complicated form, just enough to ensure they are over 18, and that they will allow their image to be used commercially. Typically, the form mentions numerous potential uses and are vital if you want to sell the image via an image library.

Defamation: you'll have no doubt heard of countless cases raised against tabloids who print stories that people vehemently deny and subsequently challenge. The same rights are available against images. If you take an image which you intend to use in an advert which, for example, implies the person photographed is a drug addict or breaking the law, you can find the photo can quickly backfire.

You might enjoy taking photos of landscapes but remember if you're on English Heritage land there are likely to be terms and conditions associated with gaining entry. Unfortunately the onus is very much on you to find out. Just because you are

not challenged or there's nothing on the ticket doesn't mean it's okay. If your images are published against copyright, any money you earned will be taken from you.

Finally if you would like to become a portrait or commercial photographer of children you first need to go through a procedure called Disclosure. This application costs £12 and you are voluntarily checked by the Criminal Records Bureau, it's recommended you have this updated every 6 months. For more information go to www.disclosure.gov.uk

7

# Watermark your images

People love freebies and if you put your images on the Web at any kind of good quality, the odds are that you'll never get anyone buying them. People might love your shots but actually handing over cash for something they can copy and paste off your website for free, just isn't going to happen. This is where watermarking your work comes in. It isn't an ideal solution as the image itself has to be slightly obscured but it's a necessary evil to force people to open their wallets. There are numerous dedicated packages that can simplify watermarking but if you have Photoshop already this task will guide you through using it to protect your photos.

1 First of all select the file option from the top menu bar and then from the drop-down menu left-click Open to find your image.

2 Once the file has opened choose the T on the tool bar. This icon allows you to add text to the image. Move the cursor over the image where you would ideally like the text to go. Remember this isn't to compliment the photo it's to stop someone using it without your permission, so be ruthless.

3 On the top of the menu you will see several options including the size and font to be used. Also controlled here is the colour of the text. Set the colour of the font to 50% grey.

4 It's entirely up to you to choose whichever font you prefer, if these image are destined to go on your own website, try and keep the theme of the site and use the same font. It is generally advisable to choose thick fonts for maximum effect.

**5** Now that you have configured the text to your preferred style and colour, type in your name followed by a copyright logo. When done click the tick on the top bar to confirm the addition.

**6** If you're not comfortable with the size or position of the text you can then use the boxes at the corners of the text to resize or rotate it. Clicking in the centre of the text box allows you to drag the words around the photo.

**7** Next click the right mouse button on the text in the layers panel at the right of the screen and from the pop-up menu select Layer Effects. You can use any number of effects to create your watermark. However, for the purpose of this task we will use the bevel effect.

7

# Watermark your images (cont.)

**8** From this selection, move the cursor over the bevel effect, this will present you with several variations. Click on the simple inner version. In the Bevel menu you can control the lighting and angle to your liking. Confirm your choice, then back in the layers palette change the blending type to Hard Light.

**9** Finally, save this image as a JPEG and under the original name but with wm or watermark added to it. If you put these images on a website or send them to people via e-mail, you can be guaranteed they won't simply steal them.

## Jargon buster

**Compression** – there are numerous different ways of compressing images. However, they fall into two camps, lossless and lossy. When using lossless compression the image is squeezed into a smaller file but when the image is reopened the original file is identical, no information is lost in the process. TIFF files can be compressed in a lossless way. With lossy compression the file can be squashed much smaller making it more suitable for transfer or web usage but when the image is opened again the result is a representation of the original but some of the quality is lost. JPEG files carefully balance image quality against file size but the process still involves some loss of quality.

The burgeoning world of digital photography has inspired thousands of new photographers to embrace the pastime and this hasn't gone unnoticed by stock libraries who now routinely offer free membership to beginners looking to cash in on their hobby. Obviously there is lots of competition but don't let this put you off before you begin. This task will explore the process of getting your images into a stock library and give you some useful tips you can employ to improve your chances of success. First of all, be careful that you select a reputable library – there's little point producing masterpieces only to have them represented by a cobbled-together website that struggles to process orders. One good suggestion is to try finding similar images to your own in the library's stock. This way you can get a good idea about the breadth and quality of the content, as well as a feel for how intuitive the library's search engine is.

**Did you know?**

Try to make you images non-specific – capture shots that convey the idea of something. If you need some help making your image's generic, take a stroll to your local bookshop and look at the fiction paperbacks. Most modern thrillers feature simple concepts, this is the sort of photo that will earn you cash, over and over.

**Important**

Be flexible, sometimes your images will be close to what a buyer wants but not quite there, you could even end up being commissioned directly.

## Use stock libraries

1 When capturing you photos, ensure you use the top resolution available on the camera. Stock libraries typically have high demands when it comes to quality, as the image could be used for everything from website clip art right through to billboards.

2 Try to avoid any cropping of the image. If you have to make large crops to improve the composition then you need to retake it and get the shot right. This goes hand in hand with the previous point – low-resolution images aren't saleable.

7

# Use stock libraries (cont.)

**3** Try to build up a strong portfolio before approaching the stock library, people will typically find a photographer's work they prefer and then narrow their search to see what else you have to offer, the more you have, the more likely you are to increase the value of your sale.

**4** There are hundreds of reputable stock libraries but for this task we have chosen to use Fotolia at www.fotolia.co.uk. You should, however, do some research to see which site best suits your own requirements. The first step when using Fotolia is to sign up for an account, you will be asked to read through and agree to their terms and conditions.

**5** The sign-up process requires you enter your contact details but does allow you to decide whether this information can be used by any of their associates. When you are finished, you will have a login and password to manage your photos.

## Jargon buster

**EXIF** – every time you take a photo with a digital camera aside from capturing the image the camera also records all of the details of the exposure, the type of camera used and if you've entered the time and date that's recorded too. This information is embedded in the image file itself and is called an Exchangeable Image File or EXIF header.

## Timesaver tip

Accept constructive criticism, ultimately as we mentioned before, there are hundreds of people out there vying for the same business and if a art editor takes the time and trouble to offer direction don't be offended – it's probably worth taking on board.

**6** When you first log in to Fotolia, the website itself will provide you with training on what is required regarding the quality of the images and some of the legal requirements when submitting images. Fotolia will only accept JPG files over 2 million pixels. Many stock libraries, however, have much more stringent requirements.

**7** When you have completed the training you will be allowed to begin uploading images. Press the Browse button and select the files for upload.

**8** After your files have uploaded completed you can edit and manage them using the web interface. Now all you have to do is sit back and wait and if you're lucky your images will start to sell.

## Timesaver tip

Using the Web you can have access to a world market but if you want to sell images of landscapes your best customers are likely to closer to home, try linking your work to a local tourist attraction or thriving bed and breakfast operation.

# Appendix: Upgrading your digital camera

## Introduction

We understand that you have probably just bought your digital camera and are looking to develop your skills and hundreds of images before you ever entertain the idea of buying your next camera, but this section aims to offer some assistance when you do, with simple pointers to help you avoid any potential pitfalls. By breaking down the technical jargon we aim to fill in the gaps that sales people so effortlessly glide over, giving you the ammunition to ask the right questions and better still, understand their responses. We will start this chapter by looking in more detail at the elements of a digital camera.

## What we'll cover

**Understand the anatomy of a digital camera**

**Understand what megapixels are and why you should care**

**What to look for in a lens**

**Understand memory cards**

**Provide power to your camera – charge your batteries**

# Understand the anatomy of a digital camera

## Sensor

This is the heart of the digital camera, the part which records the image. There are two principal technologies that can be employed for the sensor, the first known as CCD, which is an abbreviation of Charge Couple Device, the second, CMOS or Complementary Metal Oxide Semiconductor.

## Viewfinder

Until very recently, most compact digital cameras featured a small optical viewfinder. This simple lens allows you to bring the camera up to your eye rather than using the screen at arm's length. Viewfinders are a rare animal these days as many cameras use the space for increasingly large displays.

## Display

As digital cameras share more and more features with video cameras, their displays have got larger and larger. Thankfully they have also been created with better contrast ratios and antiglare treatments so they can finally rival a basic viewfinder in bright conditions. The latest generation of compacts even incorporates touch-sensitive screens to replace many of the buttons.

## Zoom lens

Most compact digital cameras offer a three times optical zoom lens. Don't be fooled by claims of 12× or 15× lenses – these figures always include the less attractive digital zoom. If you want a bigger zoom you have to buy a bigger camera.

## Mode dial

By employing a dial most compact digital cameras can make accessing a number of scene modes intuitive, without having to navigate your way through a complex menu.

## Power switch

If you're looking for a easy-to-use compact camera, always try the power switch a couple of times. There's nothing worse than missing a shot because your camera is slow to start or you can't press the button easily.

## Built-in flash

Don't expect miracles from the standard built-in flash bulbs. They are designed to help with portraits in a darkened room, not light up a concert hall. If you really need to add light, try the flash combined with a longer exposure.

## Focus assist lamp

Confronted with a dark environment your camera may struggle to find focus. This powerful LED will add just enough illumination to help the camera pick out its subject.

## Zoom buttons/rocker

Depending on your camera, the zoom may be controlled with two buttons or perhaps a simple rocker. By moving the rocker or buttons to T you zoom in, and towards W, will zoom out.

## Avoid shutter lag

Digital cameras were for a long time tarred with the reputation that they were slow and often missed great photo opportunities as they whirred and clicked, considering your requests before finally actually taking a photo. These delays were known as shutter lag and were symptomatic of the slower processors used in the first generations of digital cameras. Modern cameras have for the most part eliminated these problems but it's still good practice to review the specifications and see what claims the manufacturers make. As a rule of thumb, if the shutter lag is documented it's unlikely to create any issues, if you can't find any reference to shutter lag, alarm bells should be ringing.

Don't be afraid to ask to test drive any potential purchases, this way you can get a feel for the responsiveness of a camera. Remember always half press the shutter release to lock the focus before completely pressing the button – this will show you the shutter lag. Other aspects of the camera to consider are the time to focus, this is often mistaken as the shutter lag and can be equally as frustrating when trying to capture spontaneous snaps of your children. Try focusing on near and distant objects in turn to see just how quick your camera can react.

## USB socket

The USB plug or socket is the standard way of transferring your photos to a computer whether it's a PC or a Mac. Check if your camera uses USB 1.1 or the newer 2.0 standard, as this will dramatically cut the time to move your photos off the camera.

## A/V socket

The A/V or audio video socket connects your camera directly to your TV, making it possible to watch a slideshow or playback any captured videos.

## Power socket

Transferring images to your computer can be a drain on the batteries. You can purchase an optional power supply which allows you to power the camera without running down its batteries.

## Microphone

Many cameras have a microphone mounted on the front to record sound in video. However, sometimes the microphone is located on the top, making it more suitable for dubbing existing stills. As with the flash, don't expect too much of these simple microphones – they don't rival those found in camcorders, yet.

## Playback

To review any images taken on the camera, either move the slider to Playback or press the green playback triangle button. Pressing this button again will switch you back to record mode.

# Understand the anatomy of a digital camera (cont.)

## Speaker

While in playback, the speaker allows you to enjoy the movies with full sound.

## Delete button

Careful with this one, pressing it gives you the option of deleting individual images or the whole lot in one go.

## Battery compartment

Typically situated on the bottom of the camera. Digital cameras use either AA batteries or lithium ion power cells.

## Memory compartment

Often shares the same compartment as the batteries. Your memory card must be installed correctly before you can start shooting. If you are in any doubt, review the memory card task on page 3.

## Indicator lights

Many cameras have two indicator lights, the first tells you when the flash is ready, the second informs you when the focus is locked in.

## Wrist strap mount

This simple loop allows you to wear the camera safely around your neck or on your wrist.

## Direct printing button

With compatible printers, this button allows you to direct print without a computer.

## Four-way navigation pad

Some digital cameras feature a four-way navigation pad. This helps you move your way around the camera's menu system.

For a digital camera to convert the available light into electronic data, the camera must incorporate millions of tiny light-sensitive photodiodes. These photodiodes then capture the light hitting them and convert the amount into data. However the process is complicated by the fact they cannot distinguish between colours. To enable the digital camera to record colours, the photodiodes have to be split into three, with each set having either a red, blue or green colour filter applied to their surface so that only that light can get through. The filtered photodiodes are then configured in a grid, so that there is always one of each colour close to another. This grid formation is known as a Bayar Pattern and is the basis of almost all digital cameras.

By putting the sensor in this mosaic style, the whole image is recorded. However, for each colour there are gaps between the data, thankfully the samples are close enough together to allow the brain of the camera to interpolate – which amounts to an educated guess at the missing bits. Each individual colour photodiode is known as a pixel, and a million of these are called a megapixel. When digital cameras were relatively new devices each new generation would boast almost twice as many as the previous generation. This meant that the quality increased dramatically as the technology improved, however now that the gains are much smaller, the benefits of six megapixel over five are far less tangible.

This hasn't stopped enthusiastic marketing departments pushing their cameras on the strength of these higher numbers. Thankfully the emphasis of camera development appears to have switched very recently and manufacturers such as Fuji have begun to try and improve the

## Understand what megapixels are and why you should care (cont.)

fundamental way the light is captured. Fuji have introduced new ideas such as splitting the photodiodes to separate highlights and mid-tones. They claim that this can increase the amount of colours that can be recorded. Perhaps a more promising technology comes from Sigma who are working with a new Foveon sensor, which uses three layers of sensors. This way, every part of the sensor can record red, blue or green with no gaps between the photodiodes. Sigma claim this layered approach will deliver the most accurate colours available. However, as this system employs the photodiodes in layers you need to divide the number of megapixels by three – which unfairly, puts a lot of people off.

If you look at the numbers emblazoned on the front of a camera's lens and feel they are as alien as the calibre of a gun, then this section is aimed at you. On every camera one of the most important components is the lens. The quality of this part, however, is much harder for most people to identify. The problem is that camera manufacturers continually harp on about megapixels and zoom, areas where simple marketing can drum home a message that bigger is better however unqualified the claims are. They very rarely expend any energy telling you about the lens used. To help you understand what the specifications of a lens mean we have included a short guide.

F. values

Focal Length

A

### F values

When you look at a zoom lens the front will typically have an F number, this figure represents the largest aperture available on the lens. The lower the number the better suited the camera will be to work in low light. As an example, a lens with F2.8 on it, might be well suited to use in low light. However, if the camera had instead, a figure of F4 it might struggle where the F2.8 could still cope. Most modern digital cameras incorporate an optical zoom lens, which will typically have two F values – these two figures detail the largest aperture at both ends of the zoom.

### Focal length

The focal length will also be present on the front of the lens. This, however, directly relates to the size of the sensors and as digital cameras use a variety of different sized sensors this information can be difficult to interpret. To make the specifications more intelligible, manufacturers provide the figures as they relate to a 35mm camera. You may need to look in the manual for this information but it gives you an idea as to the perspective offered by the camera. If the camera offers 28–105mm it will be ideal for indoor photography or group shots. If instead it starts at 38–380mm you may find the camera better for sports.

Last, also keep an eye out for optical image stabilization, this helps keep the camera steady and improves your chances of getting a sharp photo.

## For your information

### Image stabilization (electronic – optical)

One of the most common problems people experience when taking photographs is camera shake. Even tiny movements of your hands can result in images which at best lack clarity or at worst are unrecognizable. It becomes harder to hold your camera still when the elements are against you, the light is failing or you're using a powerful zoom as this magnifies the shake as well as the subject. To combat these issues manufacturers provide image stabilization. This has the effect of ironing out the movements of your hand to aid you in difficult circumstances. There are numerous types of it available, although most can be put into one of two categories: electronic and optical. Electronic stabilization uses less of the camera's sensor to capture a photo, preferring instead to use the rest to smooth the camera's movement. Optical stabilization employs the whole sensor and relies on either a correcting lens or moving sensor to counteract any movement.

For early adopters of digital cameras, memory cards were a significant outlay, often costing at least a third of the price of the camera and not really giving you a particularly large quantity of images to play with. Move forward to today and the situation has changed dramatically. Now you can purchase inexpensive cards offering you the ability to store literally hundreds of images or well in excess of an hour's worth TV quality video courteous of the latest advances in video compression. Unfortunately it's not all good news. When digital cameras were relatively new there were only three formats of memory card to choose between, now there are several times that number with new variations being released all the time. In this section we are going to look at memory types so when you think about buying your next camera it might be one of the questions that drives your purchasing decision rather than simply a consequence of it. We'll look at the different types, which ones are compatible with one another and simple maintenance to ensure you photos are safe.

We'll start by looking at the most common formats available in the market today.

## CompactFlash

As one of the oldest types of memory, CompactFlash is also one of the largest in physical dimensions and in market presence. Most professional digital cameras use CompactFlash as the primary memory format. This is because CompactFlash still offers the largest capacity cards available and typically at

CompactFlash

the lowest per Mb price, making it most suited to professional use. In the enthusiast's market however the situation is very different. Thanks in part to its size, CompactFlash is no longer used in any consumer cameras and formats like the smaller Secure Digital have all but stolen this market.

## Secure Digital

This memory format was originally created by Matsushita electronics, better known as Panasonic. The design was considerably smaller than CompactFlash and so initially at least, the cards were more expensive and offered smaller capacities. Nowadays the prices are comparable but the CompactFlash still have the edge on capacity. Secure Digital or SD card as it has been abbreviated, has grown in popularity and with each generation of compact cameras getting

Secure Digital

Memory Stick Duo

smaller they are now amongst the most popular type in any camera, and used in all Casio, Canon, Ricoh, HP and predictably Panasonic cameras.

Development never stands still and even smaller formats such as MiniSD and MicroSD have been introduced that can be used in mobile phones and also, thanks to supplied card adaptors, in digital cameras.

## Memory Stick

If your camera needs a Memory Stick then it's a safe bet you have a Sony digital camera. Designed by Sony, the Memory Stick format has seen numerous revisions over the years, changing the level of security, the speed and the physical shape of the cards. If you scan through the adverts in any camera magazine you will find numerous different types of Memory Stick

mentioned varying from Memory Stick Pro, Magicgate, Duo and now M2. With the latest generation of Sony cameras, the company has moved to its smaller, faster, Duo format which can be used with an adaptor, to work in standard Memory Stick slots. However, if you are buying memory for an old Sony camera, stick to standard Memory Stick.

## xD Picture Card

Predicting that digital cameras would need faster and faster memory cards to deal with the increasing number of megapixels in their sensors, Fujifilm, Olympus and Toshiba set about developing a new format that would be unique to their cameras and offer the speed they felt would be necessary. The fruit of this union was the xD Picture Card. This type of memory is used almost exclusively only by these three manufacturers so the price for the cards is marginally higher than more widely adopted

xD Picture Card

MMC

A

comparable cards such as SD or CompactFlash. So long as you're happy to pay for it, then xD Picture Card offers the same range of capacities as the more seasoned SD.

### SmartMedia

Developed by Fujifilm and Olympus in partnership this type of memory is no longer considered a current format, although it is still possible to purchase 128Mb cards. When looking to purchase a new camera, avoid any that utilize this type of card, it gives their age away.

### Multi Media Card

These cards look similar to Secure Digital. They are, however, fractionally slimmer and usually slower than their SD counterpart. Like Secure

Digital, MMC also has a new smaller version known as Reduced Size Multi Media Card or RS-MMC. If you camera accepts Secure Digital it will usually accept MMC.

Ultimately there is no single memory type that is better, faster or more suited to everyone's use. You always run the risk that whatever camera you purchase, it will use a type that in just two years' time will have shop assistants scratching their heads, struggling to remember a long-dead format. The best advice is to opt for a camera that has a more generic storage type used across numerous manufacturers. Currently, Secure Digital appears the most widely adopted.

# Understand memory cards (cont.) ▶

**Did you know?**

When you delete your photos you're not actually deleting them, think of your memory card like a book and your images are pages in this book. When you choose to delete your unwanted photos your camera goes to the index and removes the reference to them, apparently freeing up the space and making it impossible to view them in playback. However, if you were to somehow flick through to the pages, all the information is still there and using image recovery software its possible to get them back. The drawback to this is that over time your memory card can get corrupted and eventually even damage all the other images. To avoid problems, it's good practice to occasionally format your memory cards as this wipes the information completely – returning to our book analogy formatting removes the references and blanks the pages.

The type of battery that your new camera is going to take is hardly the most inspiring subject, but you overlook this part of a camera at your peril. Many people find when they get their first digital camera home that it uses standard AA batteries. This in itself isn't bad, it's the lack of understanding about the different types of battery that causes problems. We have put together a small guide to give you a heads up what to look for and what to avoid.

First, you have the non-rechargeable batteries, well suited to the very infrequent camera users as they don't dissipate their stored power when not in use. However they're usually not well suited for taking lots of photos as they are quickly sapped by the demands of digital cameras. They may also corrode if left in the camera for very long periods.

### Alkaline

This chemical battery is the mainstay of all standard AA batteries. If you look closely at the details of any Energiser, Duracell or other similar battery regardless of the claims it makes for longer battery life, it's likely to use alkaline and is therefore, likely to run down very quickly in any digital camera.

### Oxyride

This is a relative newcomer to the ranks of AA batteries introduced by Panasonic and claiming to offer three times the life of standard alkaline power cells – sounds promising.

Alkaline

A

### Lithium

Anyone who has used a standard film camera may be familiar with this type already long favoured in film cameras. Lithium has a long life and delivers a lot of power, unfortunately this extra juice takes a much greater toll on your wallet.

The next type of battery is the rechargeable. These can be reused over and over again making them a better bet for the environment. Although the initial outlay for batteries and charger can be several times that for standard batteries, they are a better long-term solution for the health of your bank balance. The down-side is that they lose their charge whether you use them or not which can mean infrequent users often find the camera is nearly flat every time they go to use it.

# Provide power to your camera – charge your batteries (cont.)

## Nickel Metal Hydride

NiMH as they are known, is the basis of all AA rechargeable batteries. NiMH batteries come in a range of capacities indicated by their mAh rating. This refers to their milli ampere hour rating and typically ranges from 1300 right through to 2700. As the capacity of the battery rises, the cell is able to offer more photos per charge. However, along with its capacity, the time they take to recharge also increases. Some of the better battery chargers now offer the ability to refresh a full set of batteries in just 15 minutes. To do this the batteries need to be designed specifically for the charger which intelligently charges them while monitoring the temperature and blasting them with a powerful cooling fan.

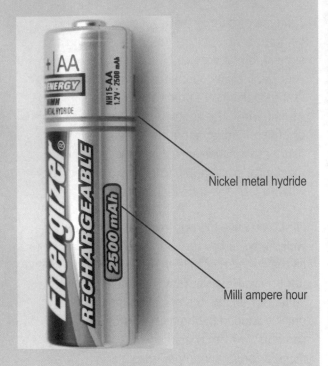

Nickel metal hydride

Milli ampere hour

## Lithium Ion

This type of battery is among the most desirable, with the best size-to-power ratio. They are normally purpose-built for an individual model of camera, although there have been some new CRV3 cells designed to work with cameras that accept this more universal format. Another benefit of lithium ion batteries is that they lose their charge at a much slower rate than NiMH batteries, making them more suitable for people who take fewer photos. Their design, however, is unique to each model so you can't just pop to the corner shop when they run out, as you can with AA batteries.

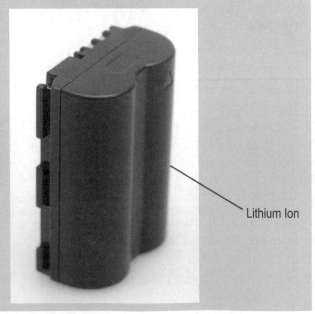

Lithium Ion

# Jargon buster

**35mm equivalence** – the standard measurements adopted by manufacturers, given that digital cameras have differing sizes of sensors, to give an idea on the focal range of a camera lens, for example, a typical 3x optical zoom would be an equivalent of 35-105mm.

**AF servo** – refers to a camera's ability to continually focus on a moving subject, sometimes called AI Servo or Continuous. This focus mode is ideally suited to use with sports events or motor sports. To start the process of focusing the shutter release typically needs to be half pressed – on higher-end cameras, the camera will even continue to adjust its focus as the image is recorded.

**Aperture** – the hole through which the light travels. In photography, the term is used to describe the diameter of the diaphragm, which controls the access of light. Using a larger opening, more light comes in, creating an image with a shallower depth of field, with a smaller opening the camera takes longer to get the same light, but the image has a larger depth of field.

**Aperture priority** – cameras equipped with this mode allow you to select your desired aperture value, whilst automatically adjusting the shutter speed to ensure the exposure is still correct for the image. Aperture priority mode can be useful for controlling depth of field.

**Artefact** – most commonly used to describe problems attributed to the JPEG compression used by digital cameras. JPEG compression allows many more images to be stored on a memory card than would otherwise be possible but poor implementation can introduce a stepped appearance to normally smooth lines, or unwanted patches in solid colours.

**Auto-bracketing** – this is taking a series of shots, usually between three and five, with exposures slightly above and below the suggested metered exposure. It is used to deal with situations where there are both very bright and very dark elements.

**Backlit** – this is where a sitter is photographed with their back to a bright light source which can fool the camera into capturing them as a silhouette. This is caused by the camera trying to weigh up the darkness of the subject and the brilliance of the background. Using a fill-in flash can help to balance the image and ensure the subject is correctly captured.

**Barrel distortion** – this describes the effect where, for example, the lines of a door frame bow gently outwards. It is one of the results of the balance between flexibility and picture quality – the long zoom sought by camera buyers means that the lens has trouble ensuring the lines in the image are straight at its widest point.

**Blooming** – the millions of tiny receptors in a camera's sensor act like tiny wells. If a bright area saturates its well the excess sometimes spills into neighbouring ones. This overflow

artificially increases the brightness of the surrounding areas. To lessen or avoid this 'blooming' modern digital cameras use gating systems.

**Burst mode** – otherwise known as continuous shooting – it is when the camera takes a series of photos in rapid succession giving you more chance to get the crucial moment. Useful when photographing sports. Cameras are often quoted with a FPS or frames per second.

**CCD** – stands for Charged Couple Device, which forms the basis of most modern digital cameras. The alternative to the technology is known as CMOS or Complementary Metal Oxide Semiconductor – this was historically used for low-cost cameras as it was inferior to CCD but cost less to manufacture. However the two technologies now offer identical results at similar costs.

**Chromatic aberration** – simply means that the colours on the print are out of alignment. Different colours of light have different wavelengths which are bent by the elements of camera lenses at slightly different angles. Unless the lens has additional correcting elements the print will show slight red and blue edges on high-contrast subjects.

See also: Fringing.

**Colour accent** – this converts a colour photo into black and white leaving only one colour element such as a bridal bouquet, which provides a bold contrasting detail.

**CompactFlash** – one of the oldest memory formats and also one of the largest. This physical size means that manufacturers no longer provide support for it in compact digital cameras but in the professional field it remains a firm favourite and is used in nearly all DSLR cameras.

**Compression** – There are numerous ways of compressing images but they fall into two camps: lossless and lossy. Lossless compression is when the image is squeezed into a smaller file but when it is reopened the original file is identical, no information being lost in the process. TIFF files can be compressed in a lossless way. With lossy compression the file can be squashed much smaller making it more suitable for transfer or web usage but when the image is opened again the result is a representation of the original but some of the quality is lost. JPEG files carefully balance image quality against file size but the process still involves some loss of quality.

**Cropping** – term used to describe how photographers block out or trim off those parts of an image they don't want to use.

**Depth of field** – the distance between the nearest and furthest points that a camera has in focus. Adjusting the camera's aperture directly controls this area. Higher F numbers such as F22 can offer almost infinite depth of field, whereas lower F numbers such as F2.8 are more suitable for portraiture as they offer a very limited focus area.

**Digital zoom** – unlike an optical zoom lens, digital zoom doesn't use the lens to magnify the subject. Instead the camera discards some of the light hitting the sensor opting instead to use just the centre portion. This has the effect of making the image appear magnified. However, as less of the sensor is used it does have the drawback of reducing the picture quality.

**Electronic viewfinder** – used to simulate the experience of using a single lens reflex camera. It can relay the live image coming in through the lens without have to incorporate another bulky lens solely for the viewfinder. Another benefit of an EVF is the inclusion of the current shot settings. Often associated with cameras with powerful optical zooms.

**EXIF** – the Exchangeable Image File or EXIF header is information embedded in the image file itself. It records details of the exposure, type of camera and, if you have entered it, the time and date.

**Exposure compensation** – this allows you to override the camera's choice and force it to lighten or darken the exposure. Useful when conditions mean that the camera will struggle to produce the desired results on its own.

**Focus and recompose** – auto-focus cameras often try and focus on the centre of the scene, which may not be the part you want to be sharp. By pointing at the subject first then recomposing the image you get around this.

**Focal length** – this is the distance in mm from the centre of the lens to the focal point when the subject is at infinity and in sharp focus. In a digital camera the focus point is the sensor. Focal length is normally represented as mm on the front of the lens. However, for these figures to be useful you need to know the 35mm equivalent – everything lower than 35mm is considered wide angle, over 80mm is normally referred to as telephoto.

**Focal length multiplier** – conventional lens can be used on some digital SLR cameras but these have a smaller sensor size than conventional 35mm film, meaning that the focal length offered by the lens produces a different field of view, with a narrower perspective. This effect is known as a Focal Length Multiplier. Typically, most entry-level digital SLRs have a 1.5x or 1.6x multiplier – this means that the bundled lenses which offer such alien focal lengths as 18-55mm actually produce similar results to a more conventional 29-88mm.

**Format** – removes all data from the storage being formatted, similar to simply deleting your images but the process is more thorough.

**Fringing** – similar to chromatic aberration, and also caused by the differing wavelengths of light not being sufficiently corrected for. Fringing however, occurs at the camera's microlenses. On some sensors, tiny lenses are added to help funnel the light into the small receptors.

**Icon** – graphical representation of a mode or setting. Typically used to indicate present exposure setting such as portrait or sports mode.

**Interpolation** – use of a complex mathematical calculation to produce a larger image than was originally recorded. It has the effect of producing images that offer a higher megapixel count than the sensor itself physically offers.

**JPEG** – stands for Joint Photographic Experts Group, a committee of specialists who defined the ISO 10918-1 standard in 1992 – the term refers to a form of compression designed to significantly reduce the storage requirements of photographic images. It is a lossy compression, meaning that some of the original information, and as a result, some of the quality, is lost.

See also: Compression.

**LCD** – an abbreviation for Liquid Crystal Display – describes the technology used in most modern digital cameras to provide a real-time view-and-review screen. Often used as a generic term although manufacturers have many new technologies such as OLED – these more advanced display technologies promise to provide better battery life whilst still being big enough and bright enough to use in direct sunlight.

**Macro** – the macro setting on a camera allows you to focus the lens very closely. By focusing only a short distance from the lens, cameras can capture very fine detail on smaller subjects. Typically used for insects and plants, the icon for macro is, in fact, a simplistic flower.

**Megapixel** – one million pixels. The light coming into a camera's lens is recorded on a sensor or CCD, these sensors are made up of thousands of individual receptors known as photosites or pixels. Modern cameras are typically measured in six to eight megapixels. While it is true that the more megapixels the bigger the image is, it doesn't directly relate to quality.

**Memory card** – the digital equivalent of film, and where images are stored. (It is not sensitive to light, but it is good practice to take care of it.)

**Memory stick** – the memory format used by Sony to store images. It has numerous different physical formats with PRO, DUO and now M2. Each format is smaller, faster and has increased storage capacity to enable smoother video or faster burst speeds.

**Noise** – to photograph in low light or to use faster shutter speeds with conventional film cameras a higher ISO rated film is often used. Its chemicals react faster to light but it has a more obvious grain. Digital cameras emulate this film by amplifying the signal which can introduce unwanted coloured pixels or 'noise' into the photo.

**Pincushion distortion** – a characteristic effect of bad lens design and manufacturers trying to squeeze the most flexible zoom they can into a camera design so that the image quality can suffer – it can be seen when looking at the lines of a window, often the straight frame will curve gently inwards.

**Pixel** – short for picture element, it represents to smallest part of an image.

**PPI** – pixels per inch – a measurement of the resolution of images. If your images are going to be printed, it should be set to 300ppi, the standard resolution used by many commercial printers but for the Web, 72ppi is more suitable. Changing the ppi changes the image's output size

but it does not change the total number of pixels in the image so that there is no impact on image quality.

**RAW** – simply means raw or unprocessed, it is not an acronym. Choosing to use RAW files means that you tell the camera to leave the images alone, allowing you to make decisions on the sharpness, colour and compression of the image later when you convert it on your computer. This is instead of allowing the camera to process the image to convert it to JPEG or TIFF.

**Reflector** – a fold-out disk or panel with a reflective white, silver or gold surface. Reflectors are normally used in portrait or studio work to direct light in order to lighten any darker aspects of the image.

**Scene modes** – digital cameras include numerous scene modes to take the guesswork out of configuring the camera. For example, when taking portraits, a narrow depth of field is generally preferable as it draws attention to the model rather than the periphery. By selecting portrait mode the camera elects to use the largest available aperture.

**Shutter priority** – allows you to specify exactly what shutter speed you require to create your exposure. However, in order to achieve this the camera automatically adjusts the aperture value to ensure the exposure is still correct.

**Shutter release** – the button which releases the shutter and allows it to momentarily snap open and shut exposing the sensor to light.

**Shutter speed** – the speed at which the camera allows the shutter to open and close allowing light in to create an exposure. It is normally measured in fractions of a second, but longer exposures can be several seconds or more.

**TIFF** – stands for Tagged Image File Format. It works in a similar way to JPEG but can

compress photos without any loss of quality. TIFF files also have the advantage of being able to support layers. As a result, while some digital cameras do support TIFF files it is far more likely that you will encounter them while using a photo editing package.

**TTL-metering** – TTL stands for Through the Lens and is usually used in the context of how cameras interact with a flash. Using TTL, the required exposure is measured from the light travelling directly down the camera's lens. When firing a flash, the sensors in the camera can then adjust the flash's output to ensuring the exposure is as accurate as possible.

**TWAIN** – not officially an acronym, it stands for Toolkit Without An Interesting Name and is the industry standard for communication between scanners, printers and applications. Before it was established in 1992 getting, for example, your scanner to talk to your PC could be a very hit and miss affair.

**Unsharp mask** – a tool within modern photo editing packages used to, in fact, *sharpen* a photo. Its contradictory name originates from a printing technique that used a slightly blurred positive image combined with the original negative to create the effect that the final print was sharper.

**USB** – abbreviation for Universal Serial Bus – by far the most common way to connect a digital camera to a home computer. Identify the presence of a USB by looking for its trident icon. Unlike older methods, it allows for new accessories to be connected safely while the computer is still turned on. There are currently two types of USB, 1.1 and 2.0, the latter is over 40x faster than its predecessor.

**White balance** – digital cameras come equipped with numerous preset white balances, including tungsten, daylight, cloudy, etc. These settings are designed to compensate for the differing wavelengths of light coming from the different light sources their names represent. For example, photographing under a fluorescent strip light without selecting the correct white balance is likely to give the image a blue appearance.

# Troubleshooting guide

## Why do my photos come out blurred?

It's likely your exposure is set very long either because there isn't enough light, or you have simply selected a slow shutter speed. Try using flash by reading up on page 13 or adjusting the shutter speed in our section on shutter priority on page 37.

## Why are my photos too dark?

Could be you have accidentally disabled your flash? Check out page 13 for more details or you might need some help using the manual mode, if so read up on page 40.

## Why do my photos vary from too light to too dark?

Check your metering settings, you might find the camera is set to use spot metering, to learn more about the various metering modes turn to page 46.

## My photos all have white skies with no detail, what can I do?

Ultimately most digital cameras have to make a compromise between exposing the sky or the buildings, however you could try using auto bracketing, read more on page 48.

## How do I stop my photos appearing grainy?

Grainy photos can be caused by too little light or too high an ISO setting on the camera, check out page 43's task focused on ISO to learn more.

## Whenever I take photos indoors, they come out orange, what am I doing wrong?

Getting a strong colour cast of this nature is usually associated with the wrong white balance settings, check page 94 to get the lowdown.

## Why can't I get my prints any bigger?

If you're struggling to get enlargements printed its most likely cause is that the image resolution is set too low. Otherwise it could be you that have been using the digital zoom, learn more about digital zoom on page 10.

## Why do the eyes of my subjects always appear red?

What you're seeing is the light bouncing back from your subject's eye. There are ways to reduce this in the camera, see page 15 but if they persist you can ensure they are removed in Photoshop, see page 113.

## Can I make a black and white print colour?

If you take the photo using a digital filter as on page 87 the short answer is 'No'. However, if you have converted the image using Photoshop you might be able to go back through the file's history and restore the colour, check page 119.

## I keep taking photos but when I look at them there is nothing there, what am I doing wrong?

Many cameras allow you to continue taking photos even when the card has run out of space, or its missing altogether, have a look over page 3 to check both possibilities.

## Why do my flash photos look bleached out?

Some cameras can't cope with people standing too close to the camera, but you could try lowering the flash's power. Turn to page 56 to learn about flash compensation.